CW01022909

BYWAYS

PHOTOGRAPHS BY
Roger A Deakins

BYWAYS

Roger A Deakins

I am not a still photographer, and I won't pretend to be one at this stage in my career. I have spent almost half a century enjoying my life as a cinematographer, during which time I have photographed both documentaries and something like seventy feature films. But, growing up in Devon in the early 1960s, films were to be enjoyed only as a viewer and were in no other way connected to my own reality. As a teenager knowing more clearly what I didn't want to do with my life than what I did, I left home for Art College. Maybe I was driven by a passion for painting, but more likely this was my way to escape the life for which I seemed destined. Either way, at Bath Academy of Art I developed my passion for capturing images through a lens rather than with a brush. On weekends I would hitch-hike to Bristol and explore the city streets or to Bournemouth or Weston-Super-Mare, sometimes sleeping on the beach in order to catch the early morning light. My dream was that I might find a career as a photographer but a chance conversation with a fellow student led me to look in another direction. I had always loved the cinema but, until I discovered that the National Film School was to open its doors for the first time in 1971, I hadn't considered it as a career possibility. Now that the seed had been planted, the rejection of my initial application only made me more determined to gain a place the following year.

As luck would have it, on leaving Bath Academy of Art I was offered a job as a photographer at the Beaford Arts Centre in North Devon. My brief was simply to reflect the life of the area with a view to holding exhibitions in local shop windows or village halls. I believe the time I spent wandering the byways of North Devon played a crucial part in my development as a documentary film maker, and not only in that it provided me with a stronger application to the National Film School. I have often thought about these images from fifty years ago and I am thankful to have the opportunity to reproduce some for this collection.

My love affair with the South West of England is reflected in the subsequent series of images, many of which come from more recent periods of 'down time' between film projects.

In the early days of my career as a cinematographer, my focus was exclusively on my film work and I rarely carried a still camera. Regrettably, with hindsight, this collection contains no images from my time shooting film projects in India, Eritrea, Sudan, Gambia, Kenya, Zimbabwe or South Africa, though a few do come from one of my first professional as-

signments, which was to film a documentary aboard one of the entrants in the Whitbread Round the World Yacht Race. Most of the images I have from that nine-month experience were either captured with my film camera or, more often than not, remain fixed inside my head rather than in a dark room. Both being a member of the crew and shooting a documentary film left little time for a still camera, so the six images reproduced here give only the briefest glimpse of those memories.

Although photography has remained one of my few hobbies, more often it is an excuse to spend many hours just walking, my camera over my shoulder and with no particular purpose but to observe. Some of the images in this collection, such as those from Rapa Nui, New Zealand and Australia, I took whilst travelling with my wife, James. Others, such as those from Berlin and Budapest, are images that caught my eye as I was 'walking' on a weekend or at the end of a day, whilst working on a film project in those cities. After we had wrapped our shooting day on 'Sicario' in New Mexico, I would often spend the last of the light looking for another shot, but this time with my still camera. Sometimes, I would drive to the same location and wait for a late day thunderstorm to produce the shot I had pictured in my mind such as that of the lightning bolt. The shot of Salisbury Plain in the dusk was taken at the end of a day of scouting locations for '1917' and the lone tree features in the final frames of that film.

The choice of when to take a picture and which of the resultant images has a future, reveals something of us as individuals. Each of us see differently. We are drawn to subjects that resonate with us personally and our interpretations differ through our choice of camera angle and composition. Without a detailed explanation of how and why a picture came about, can it mean the same to the viewer as it does to the photographer? Knowing that the image of the eagle was taken in Romania and is of a statue that stands sentinel over a German war grave can only change the relationship between the photograph and the viewer. Maybe a photograph should stand alone, and I would like to think these can, but I have also given some context to each in the index.

Why a book? Maybe it is vanity. Some of these pictures, especially those from North Devon and the seaside towns of the South West of England, I wish to see preserved as a record of a time and a place, whilst others are purely images that connect with me as I would hope they do with the viewer. My work as a cinematographer is a collaborative experience and, at least when a film is successful, the results are seen by a wide audience. On the other hand, I have rarely shared my personal photographs and never as a collection. And they are personal. For the most part they have little connection, other than one of geography, to the films I have worked on.

The first photographs in this collection reflect the working life of a farmer, Ivor Bourne, and his two laborers: Tom Hooper, pictured opposite, and his young partner, Derek Bright.

Pages 22 - 50 reflect various aspects of North Devon life in the early 1970s, from the otter hunt and stag hunt to the livestock market, the air show to the town carnival, the flower show to the fairground.

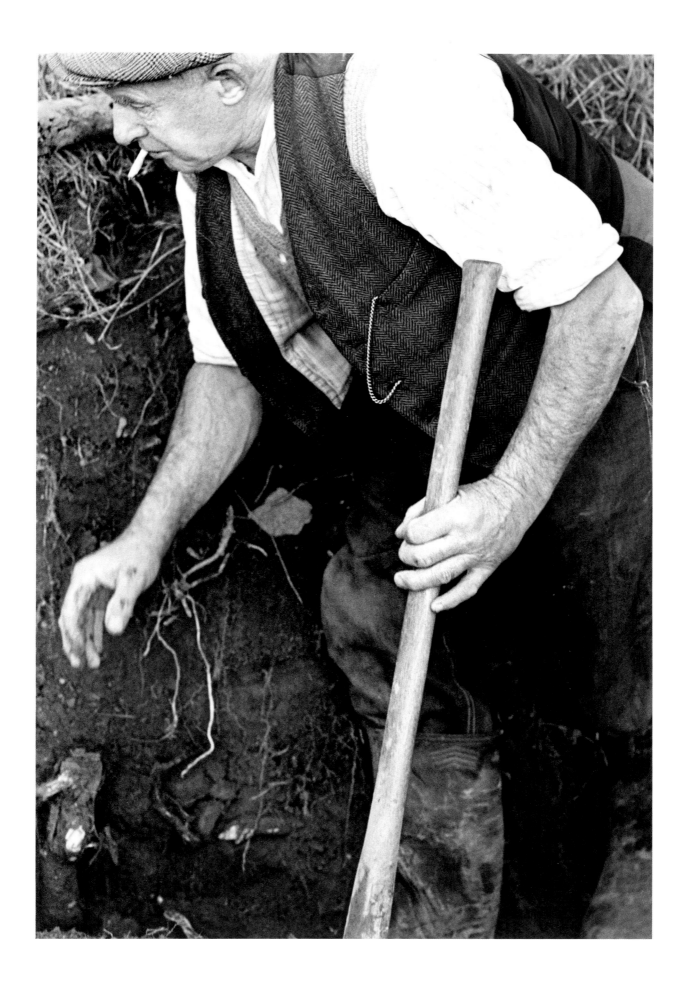

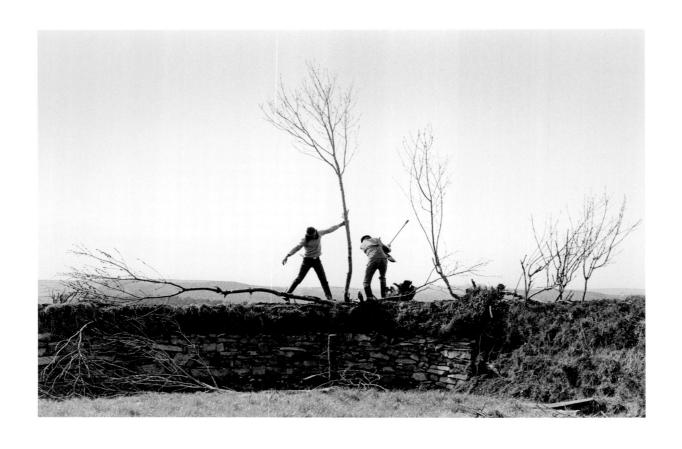

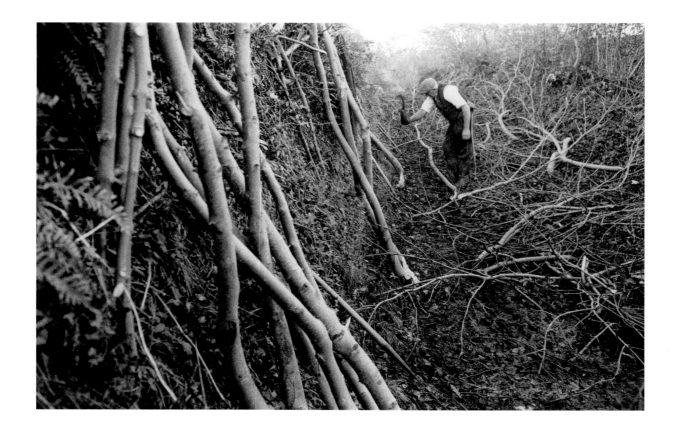

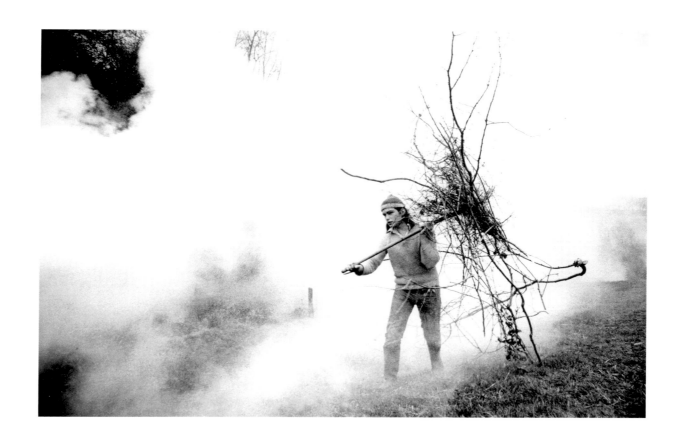

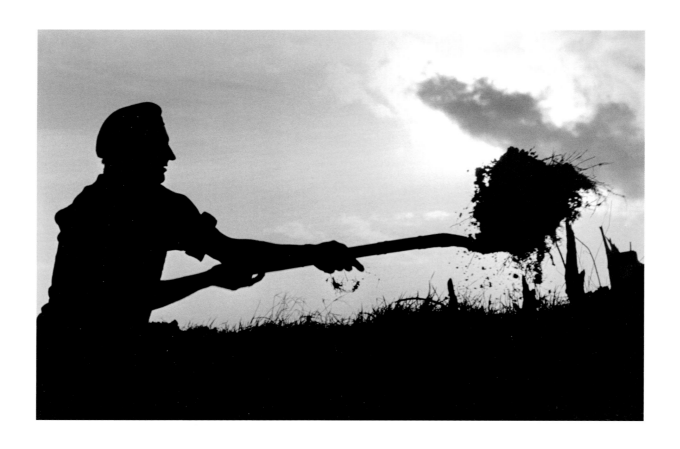

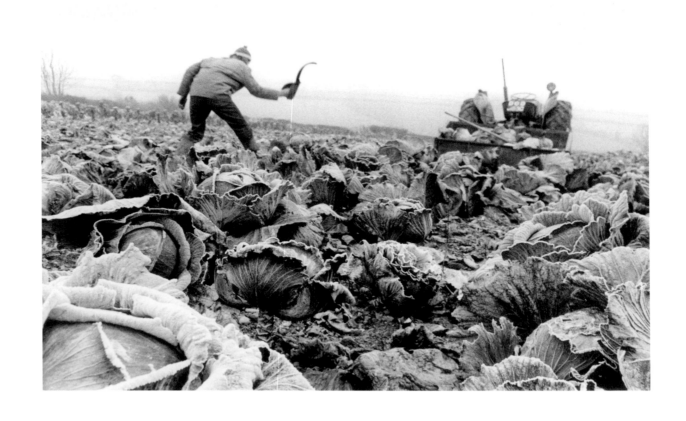

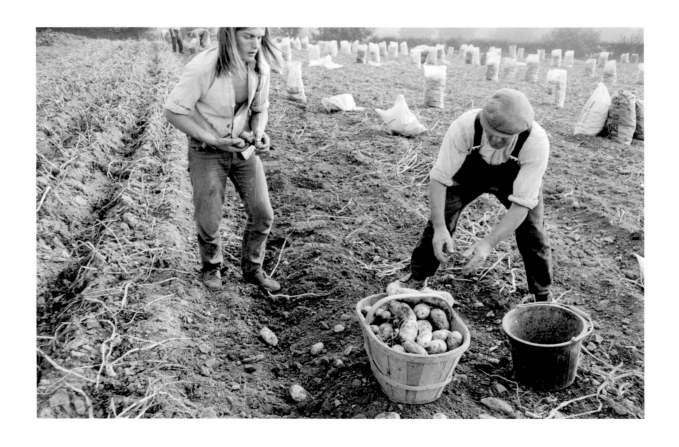

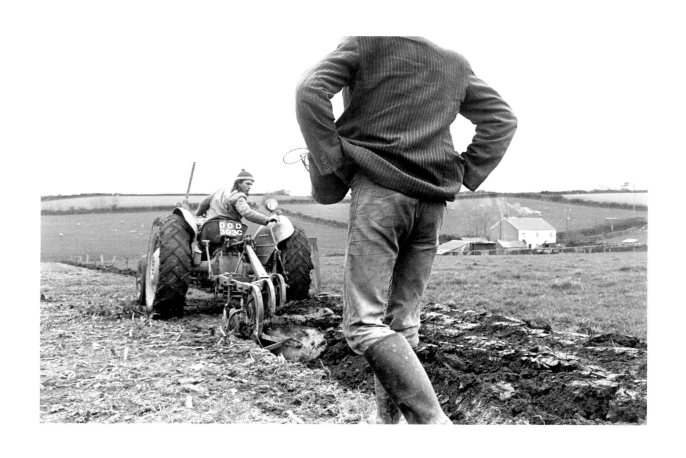

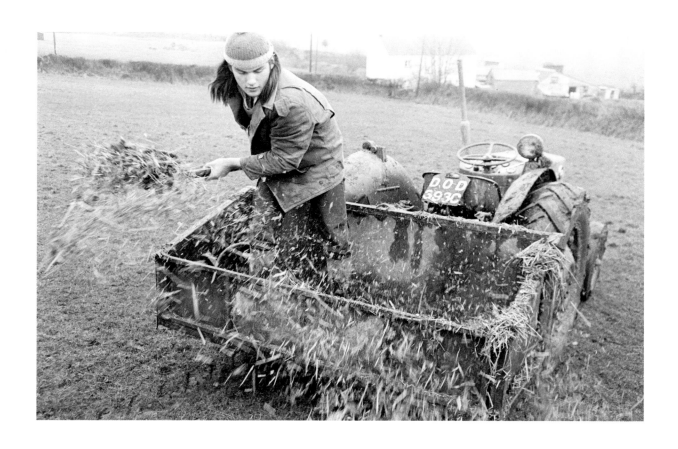

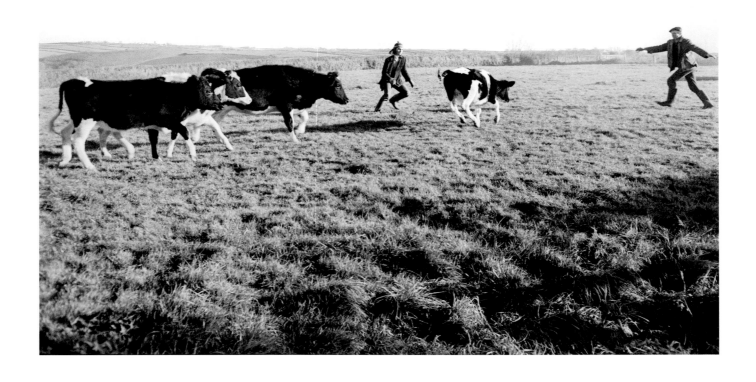

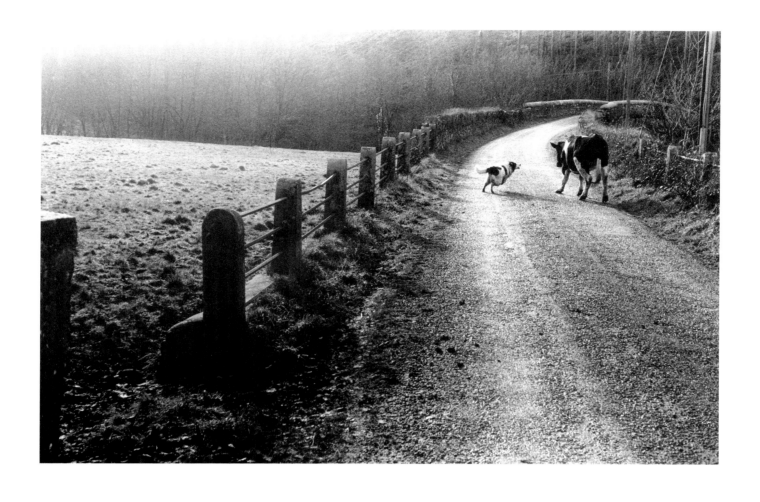

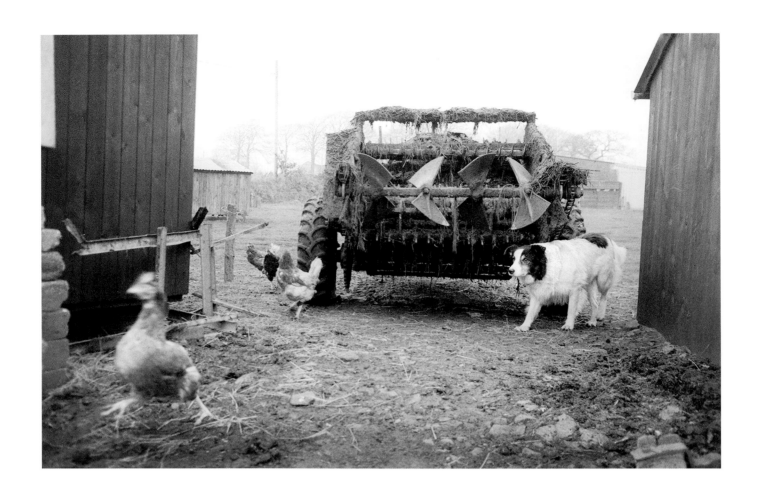

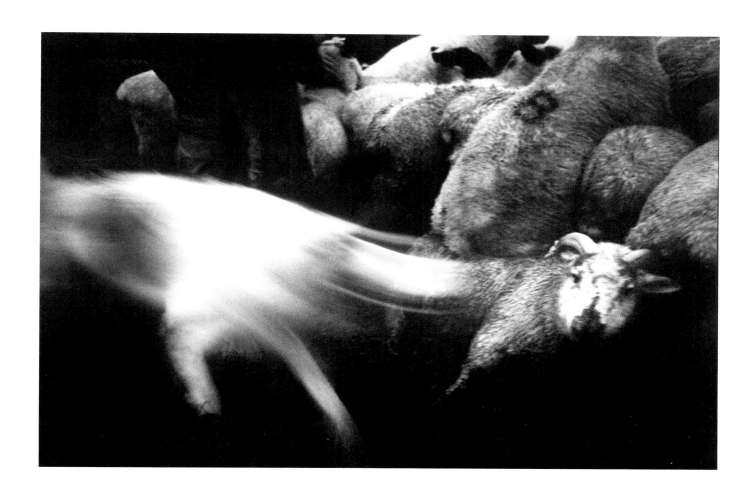

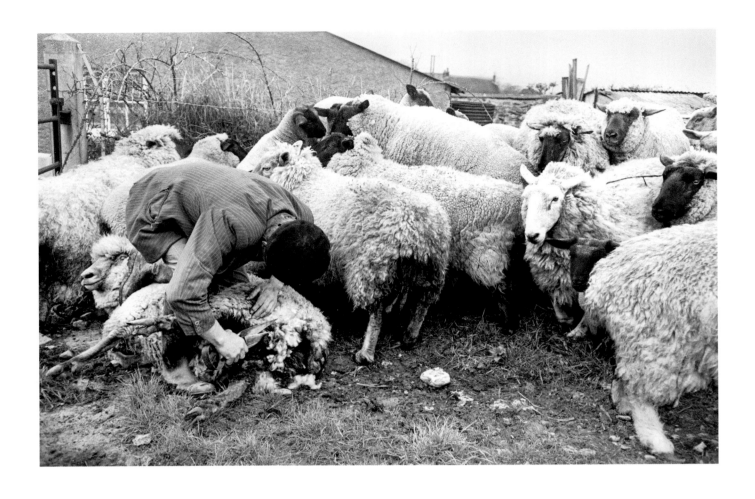

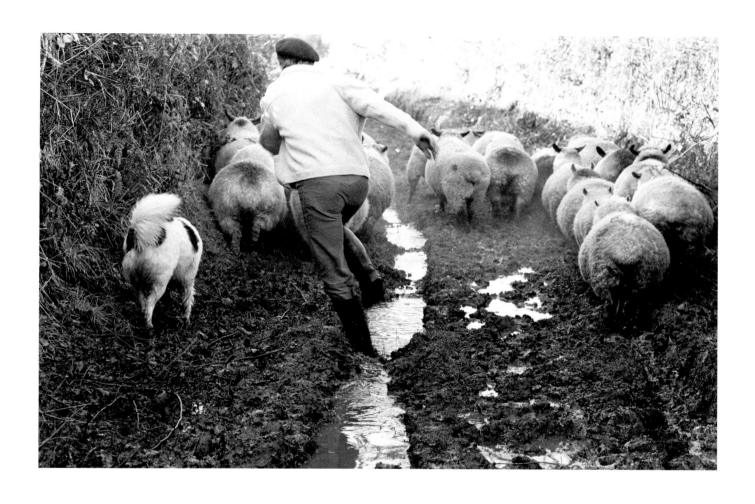

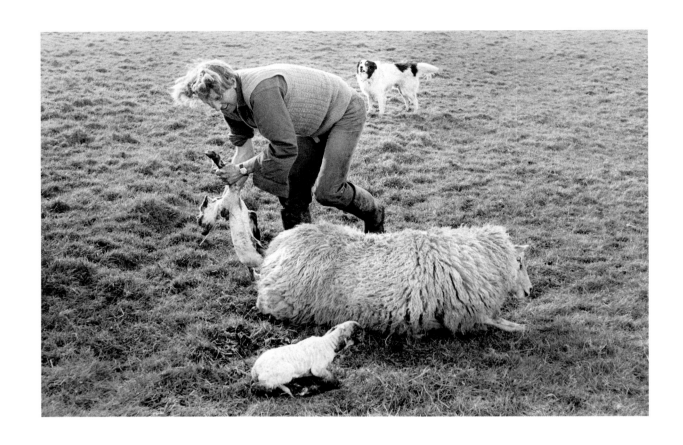

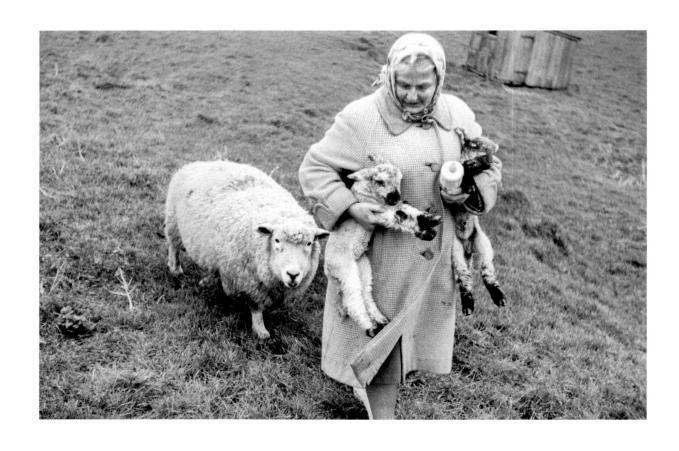

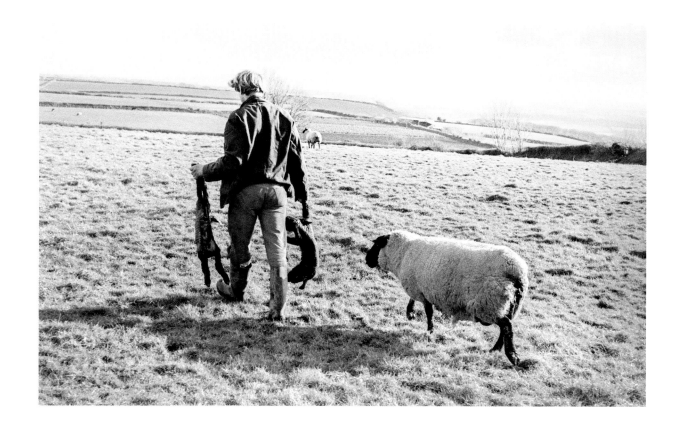

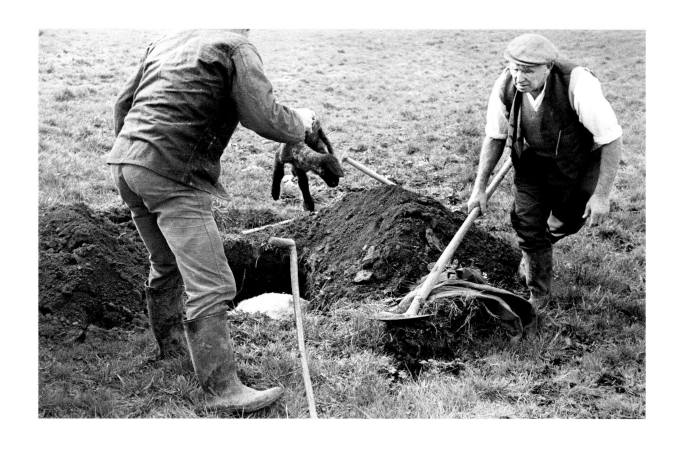

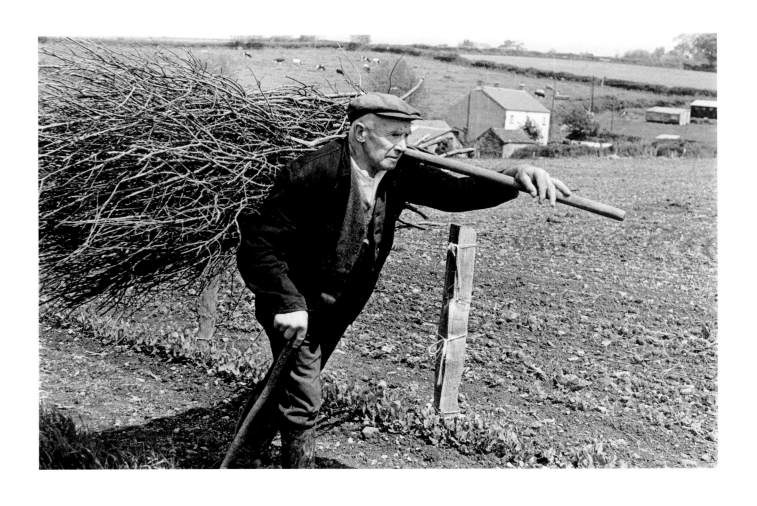

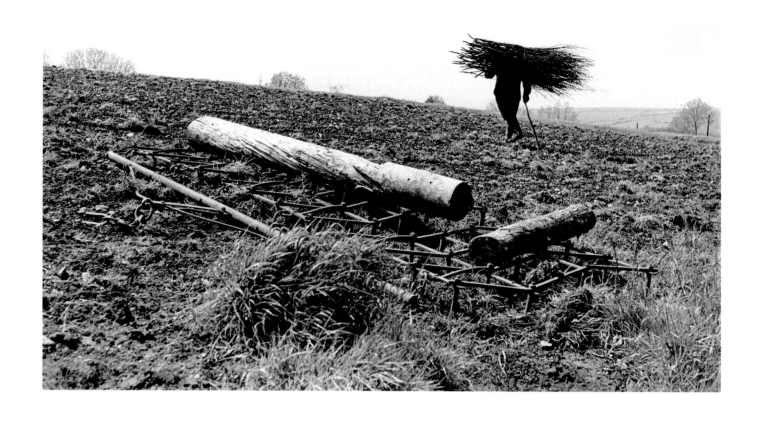

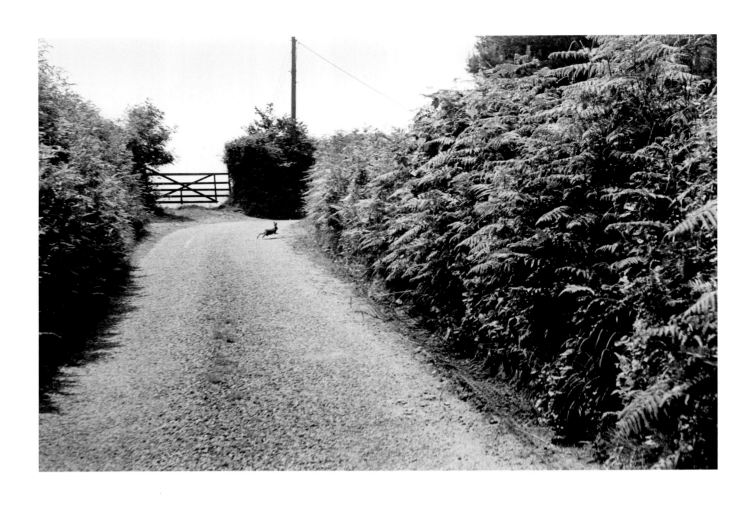

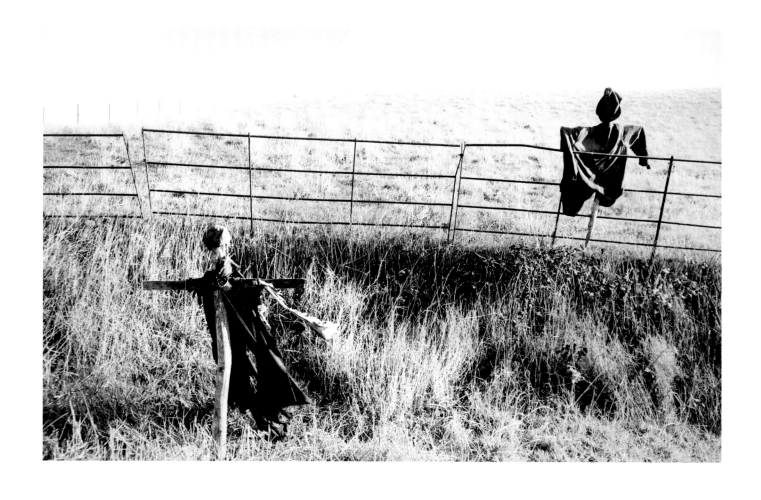

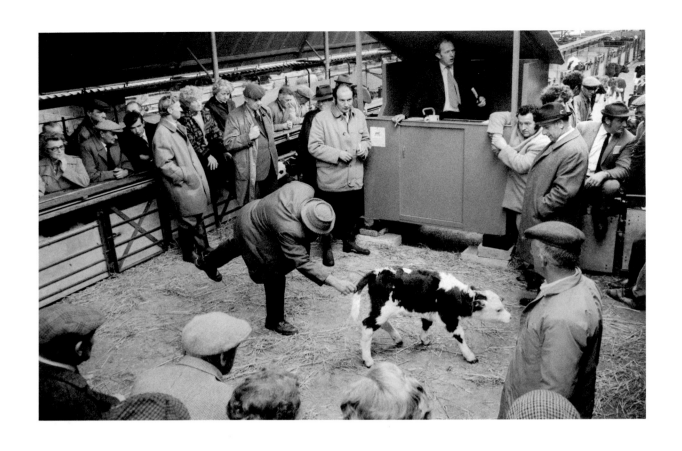

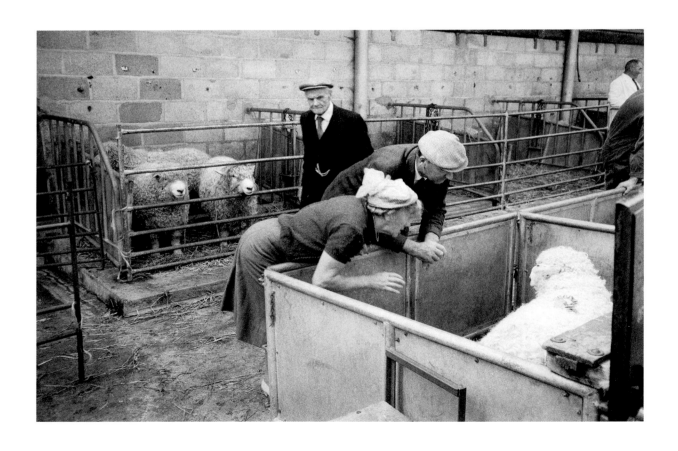

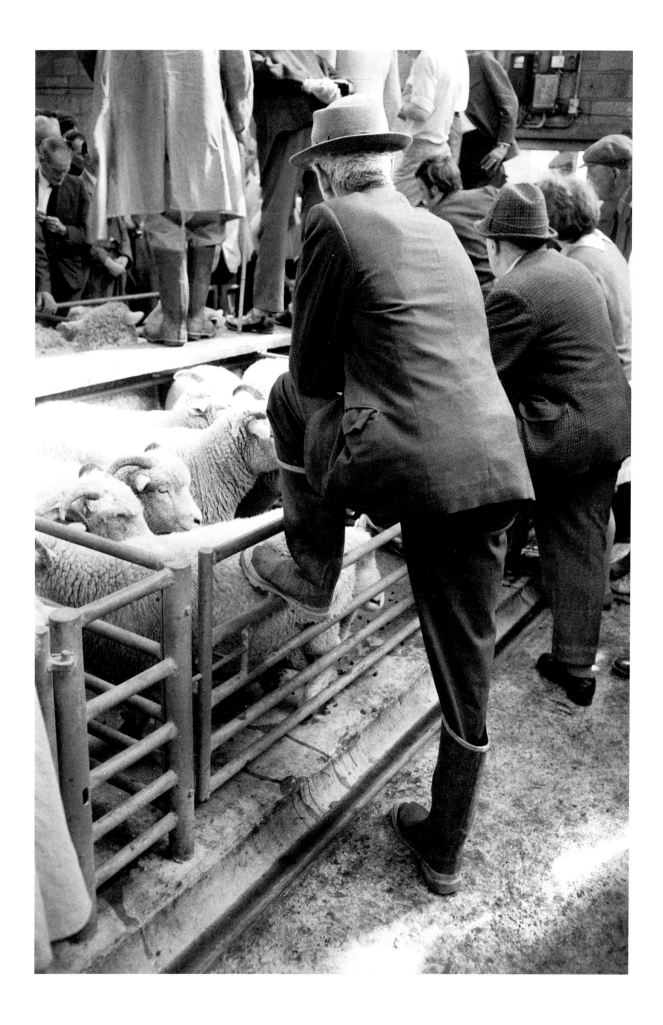

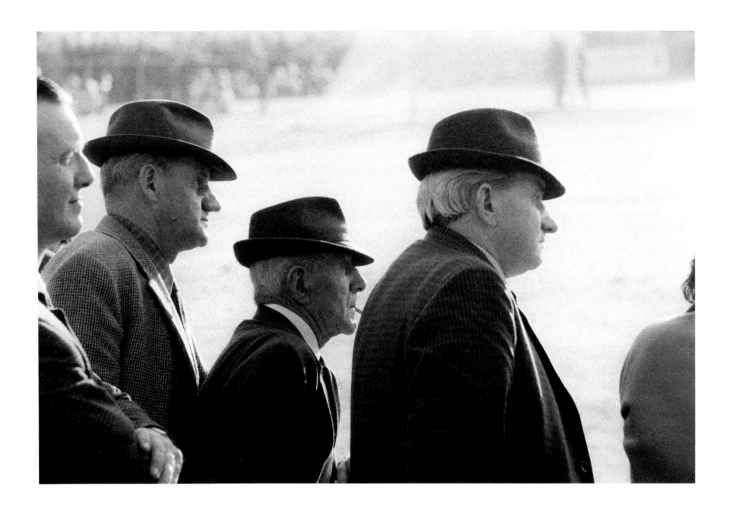

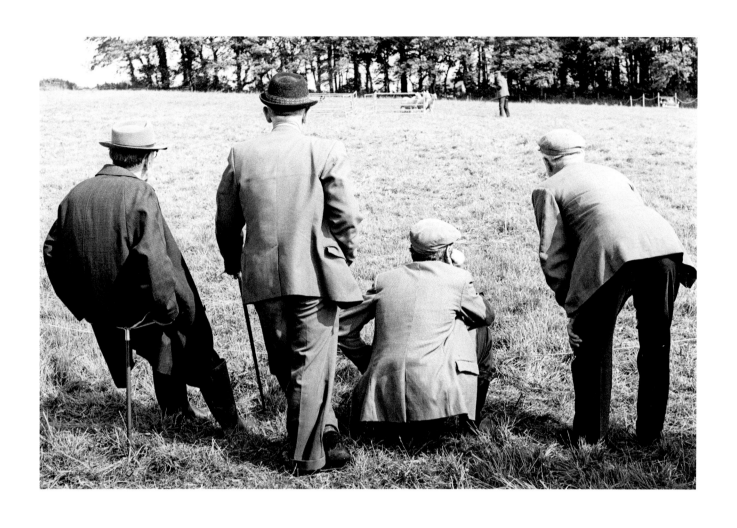

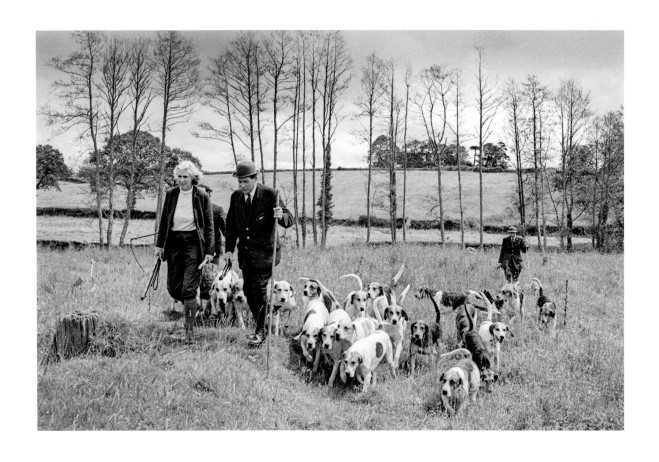

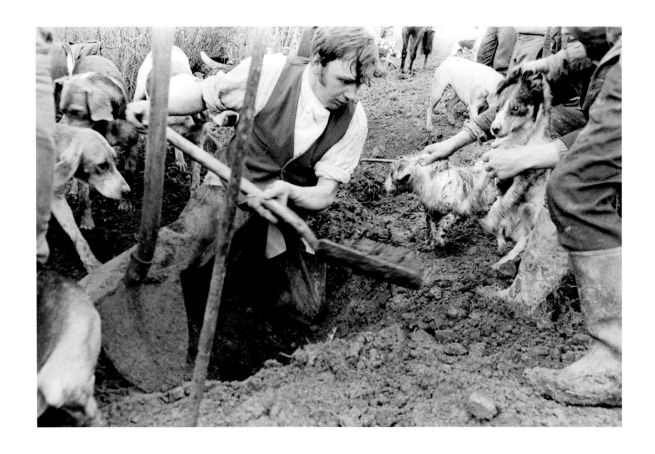

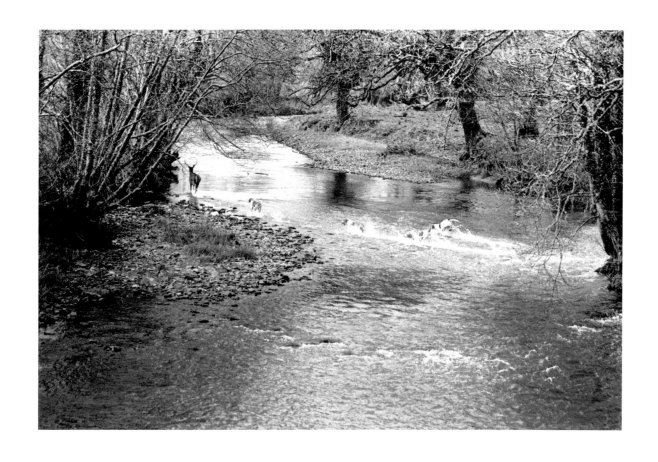

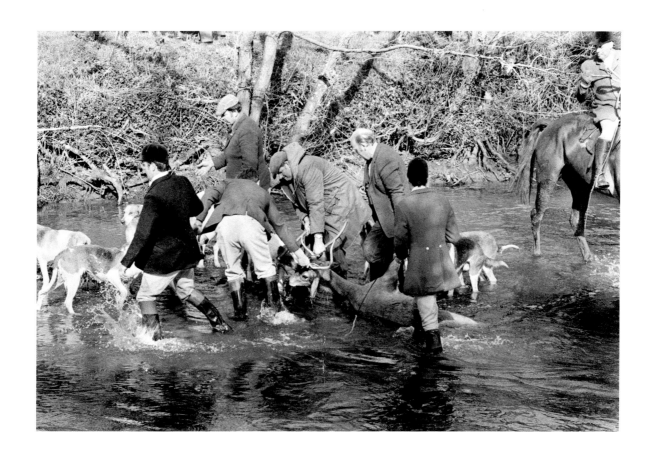

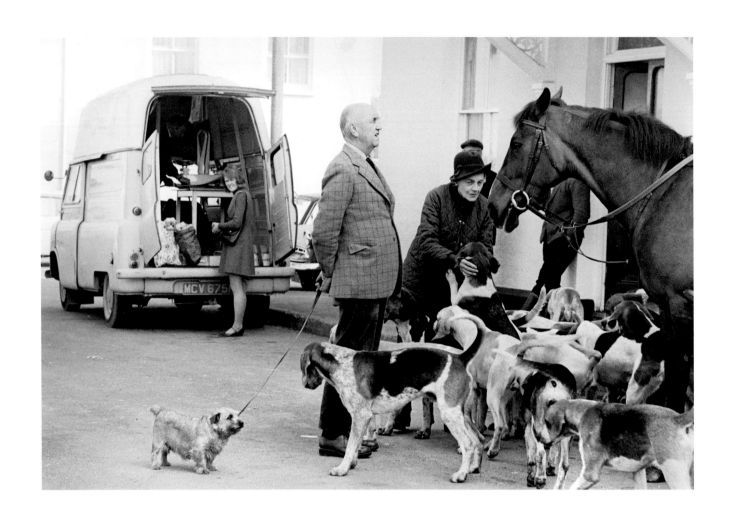

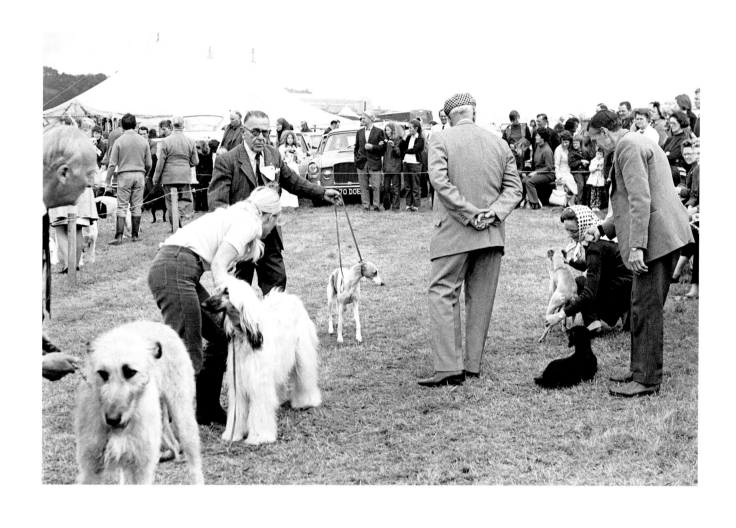

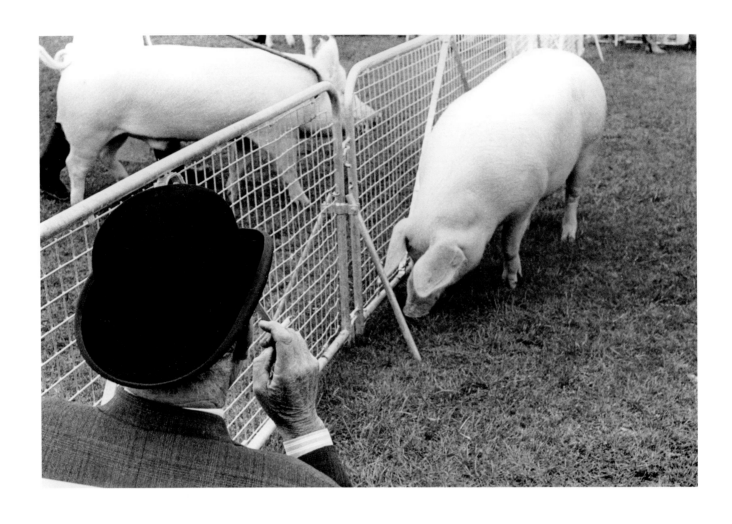

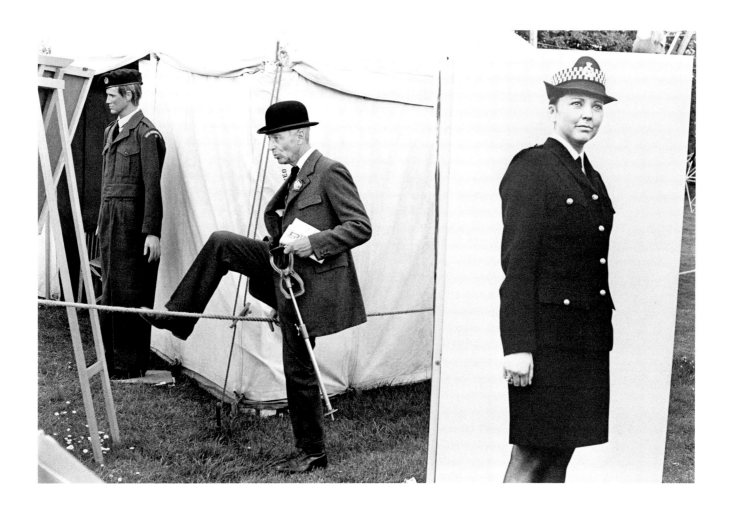

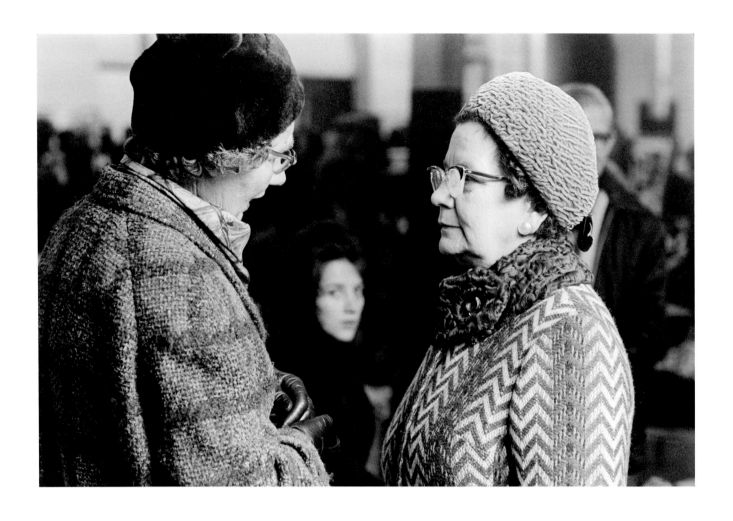

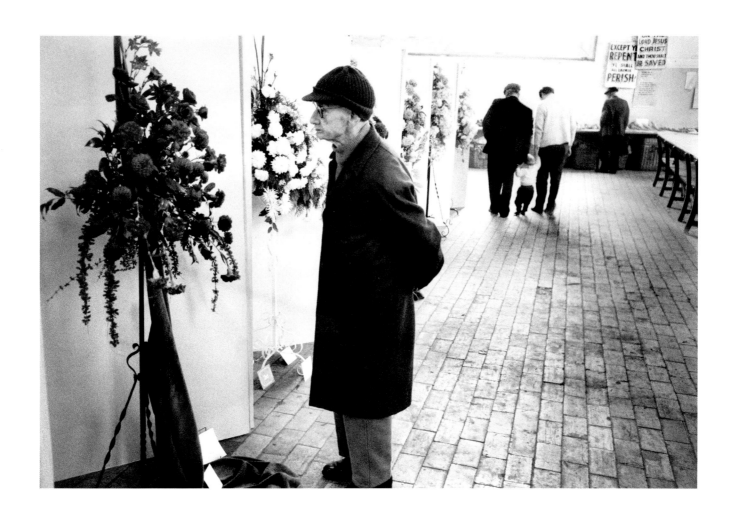

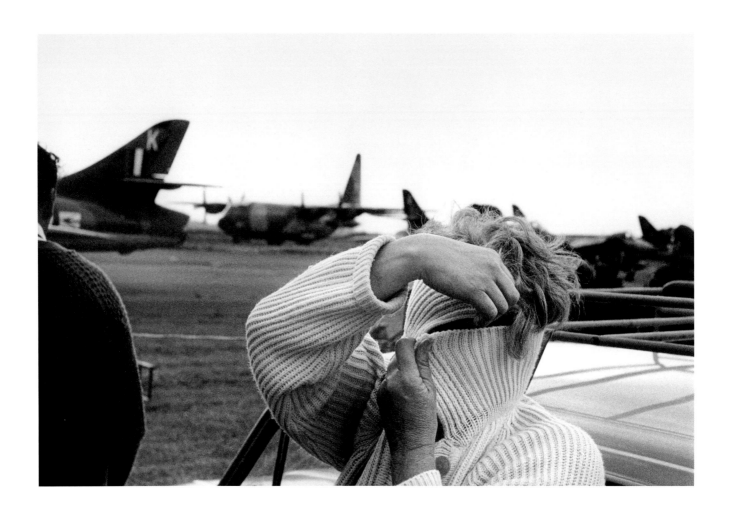

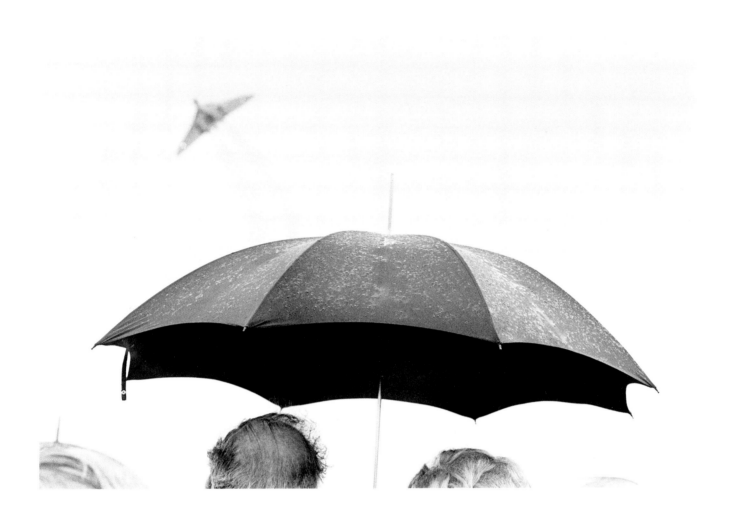

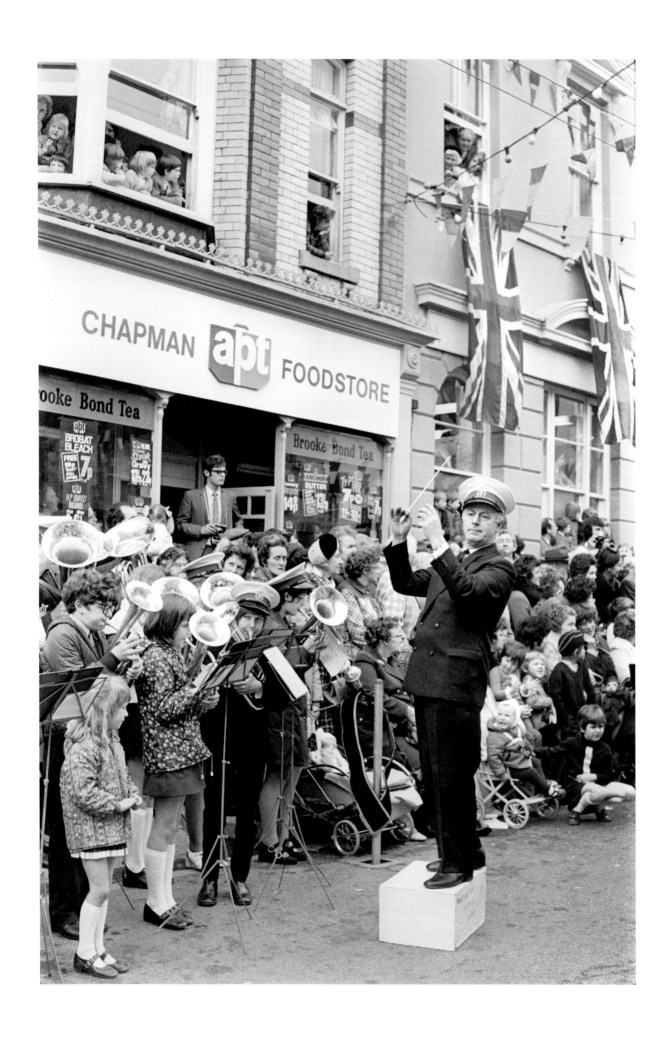

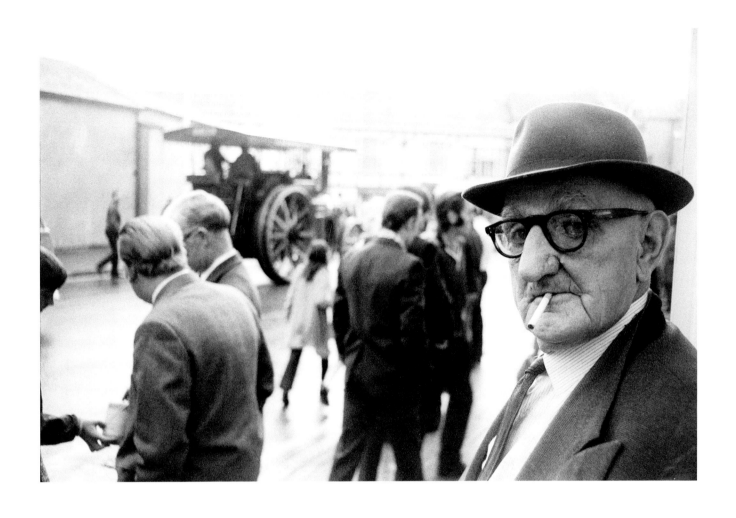

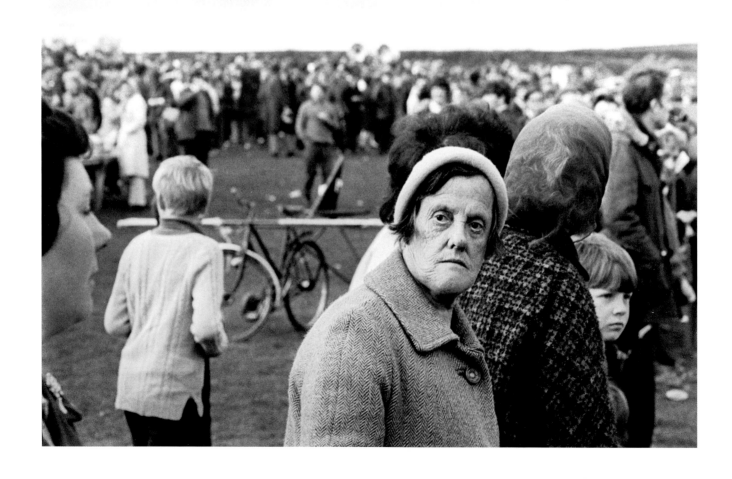

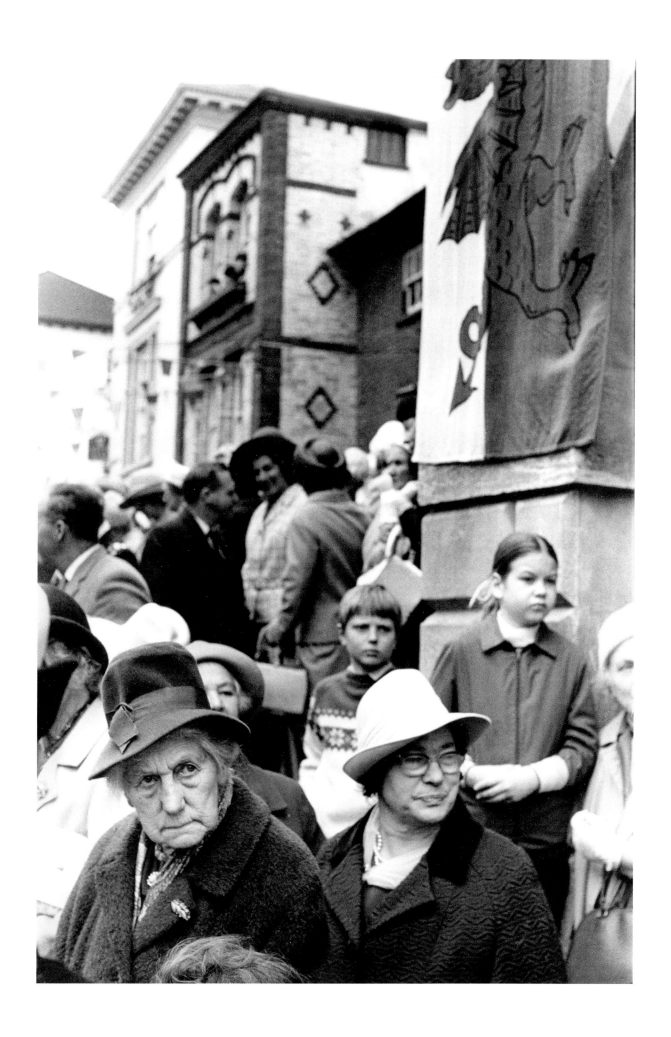

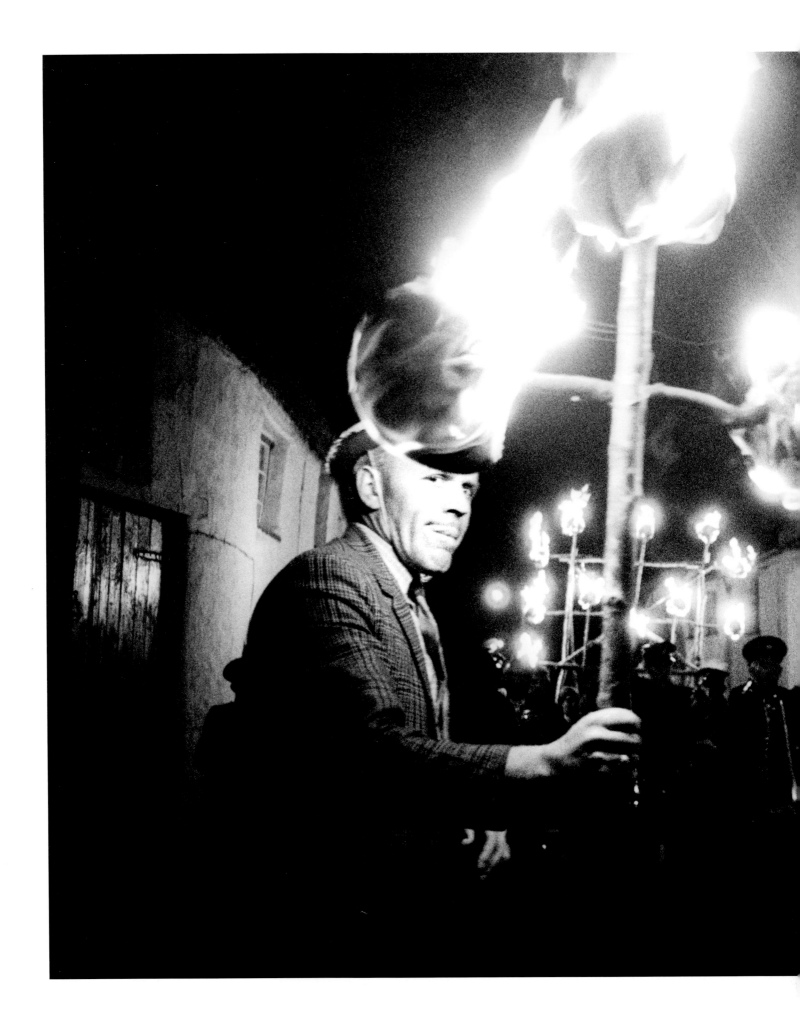

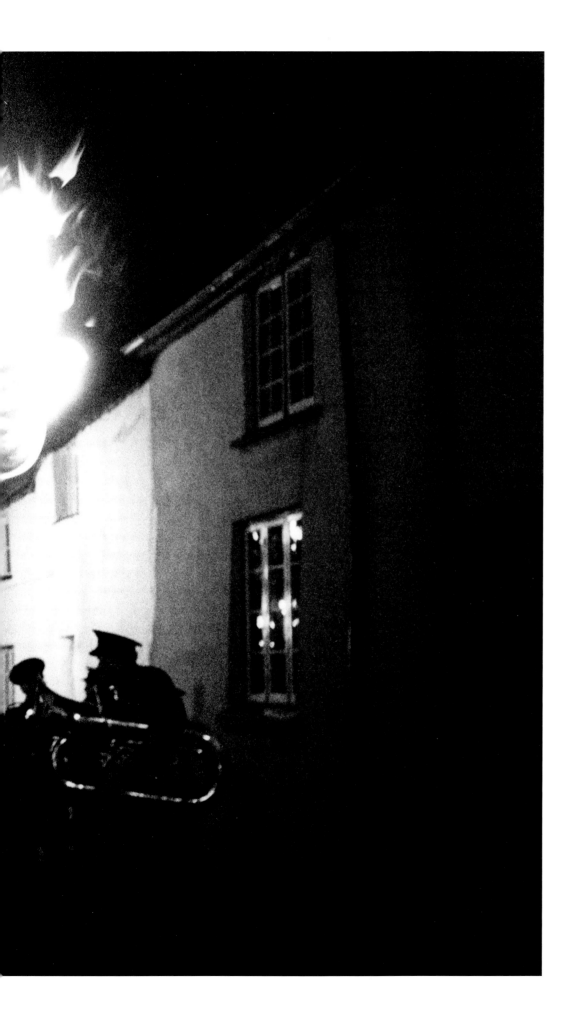

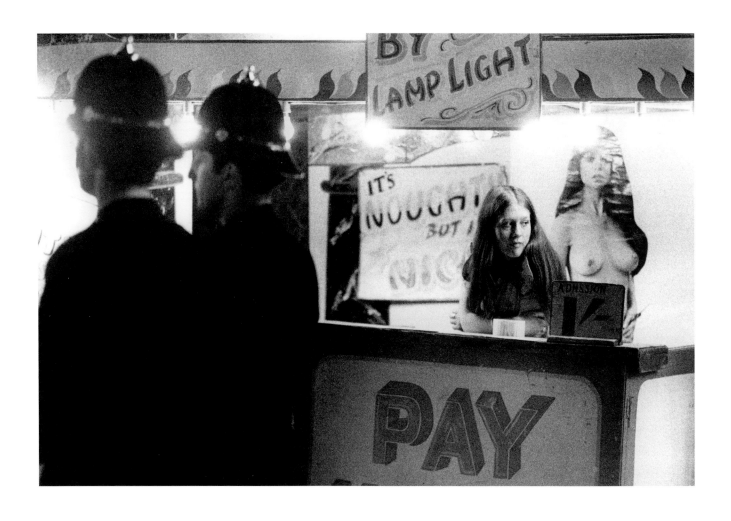

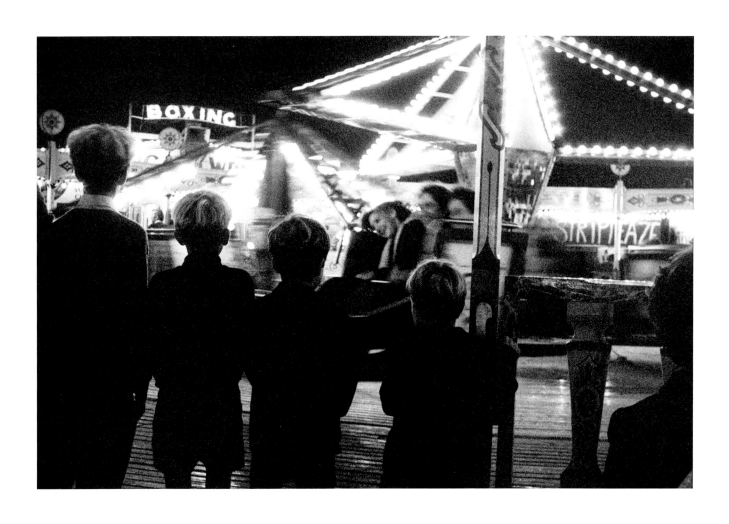

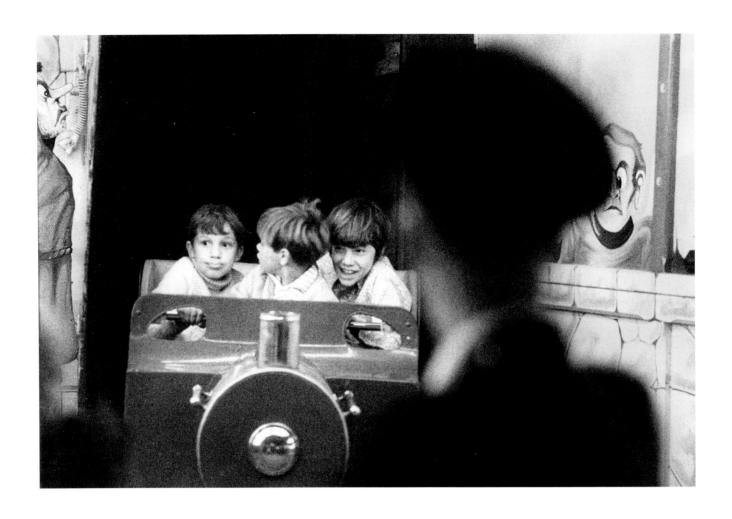

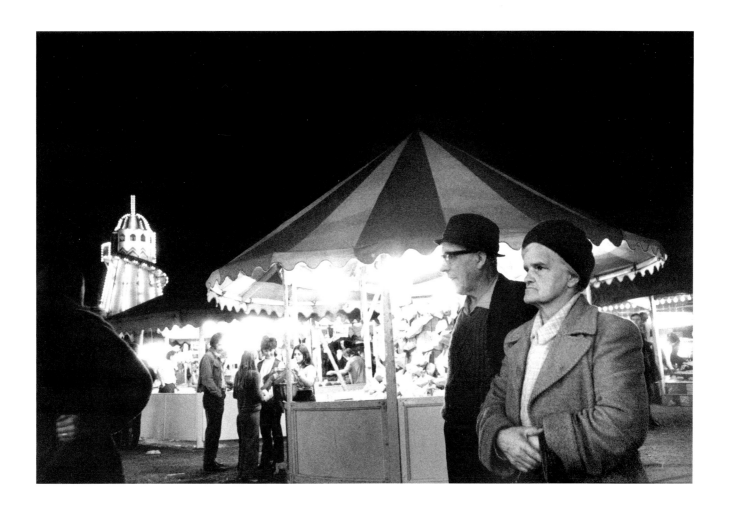

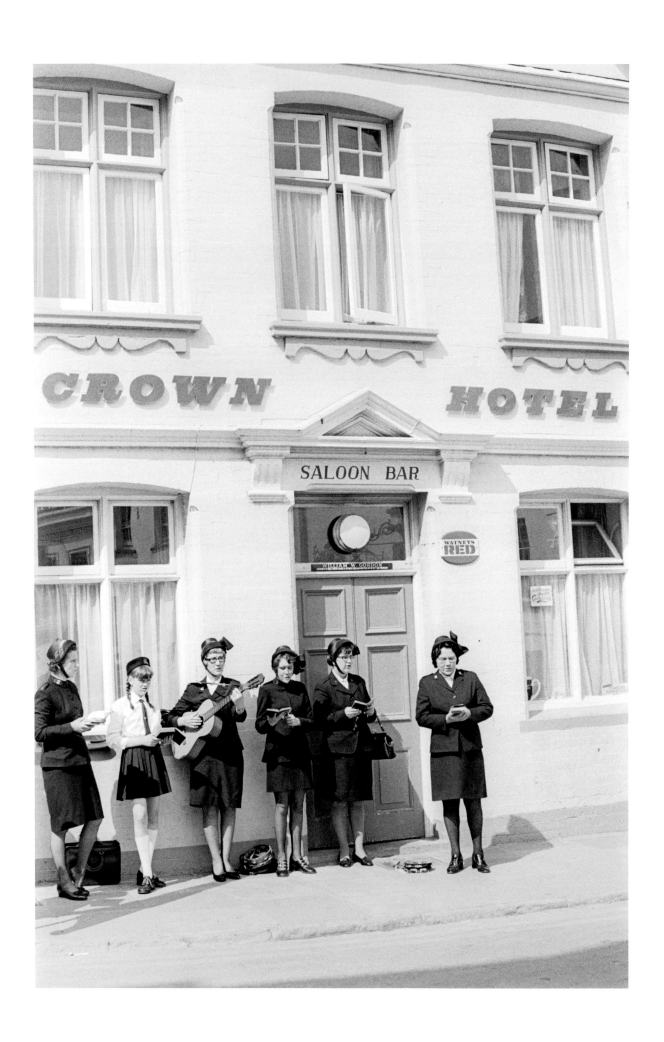

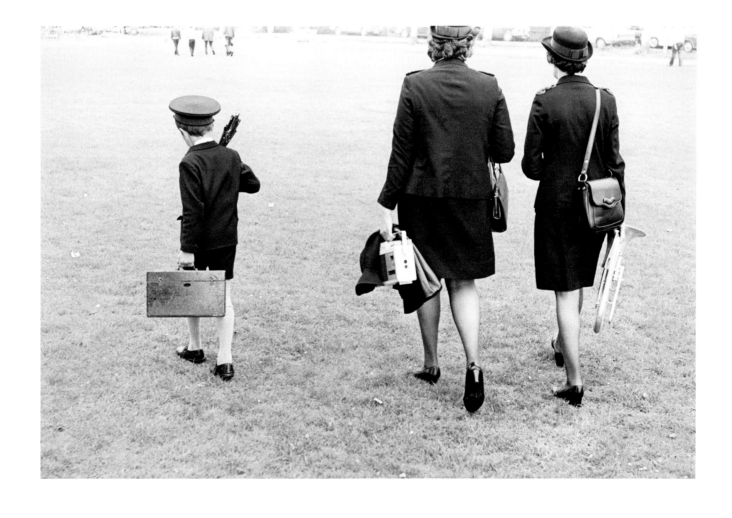

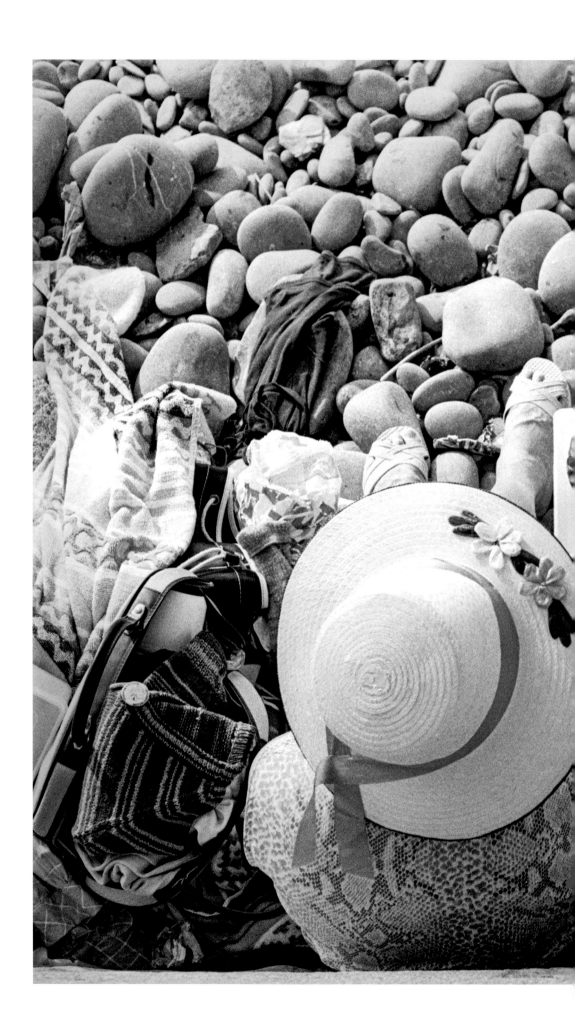

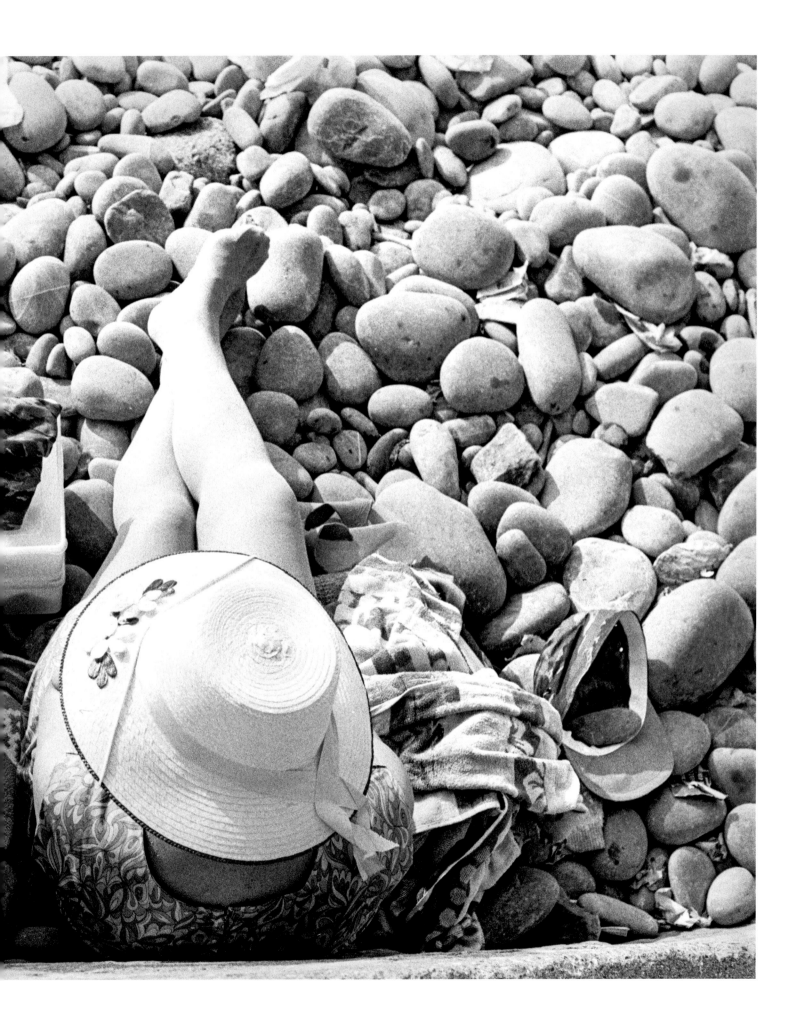

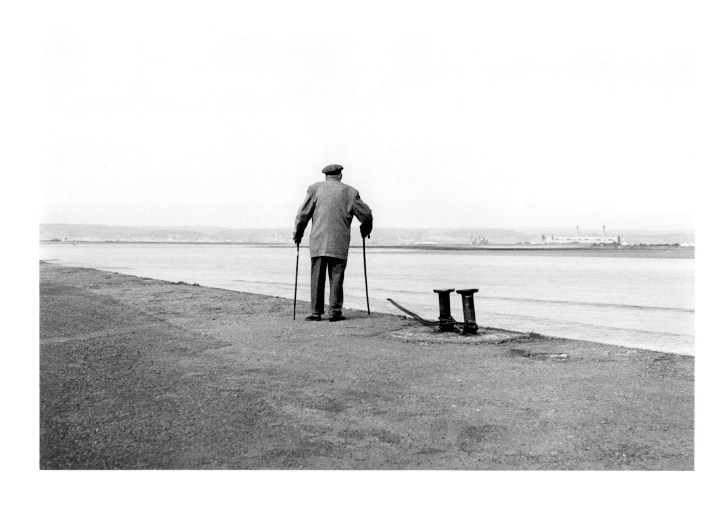

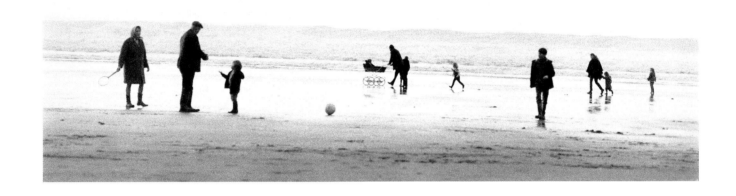

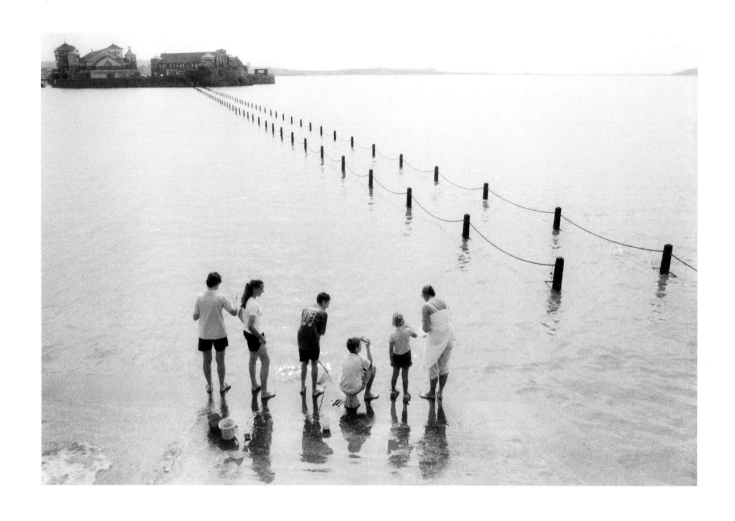

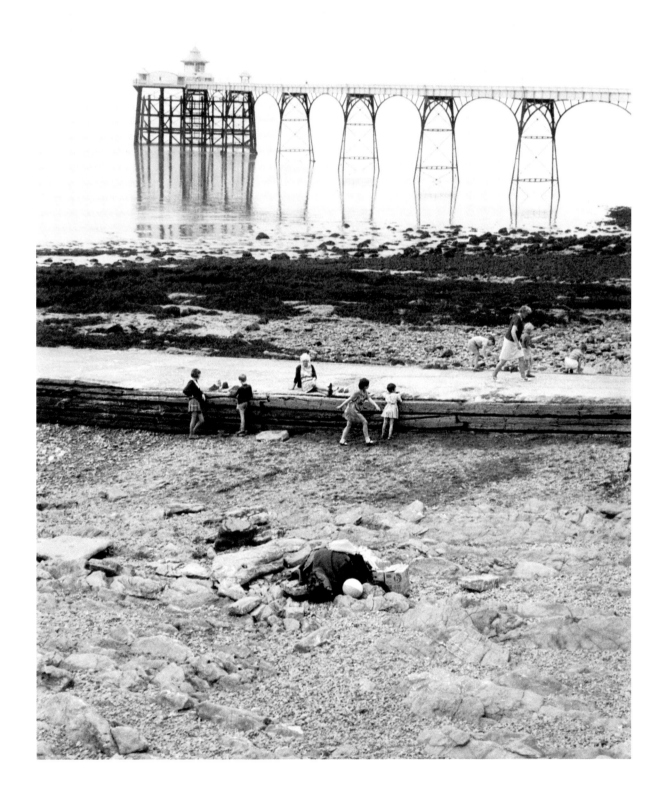

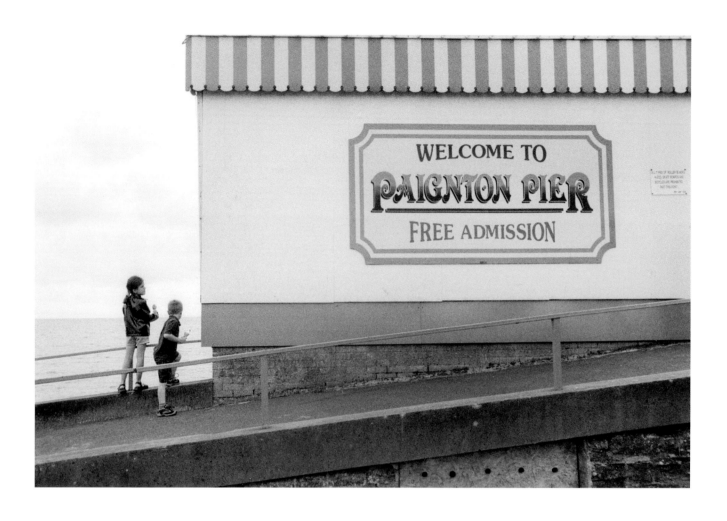

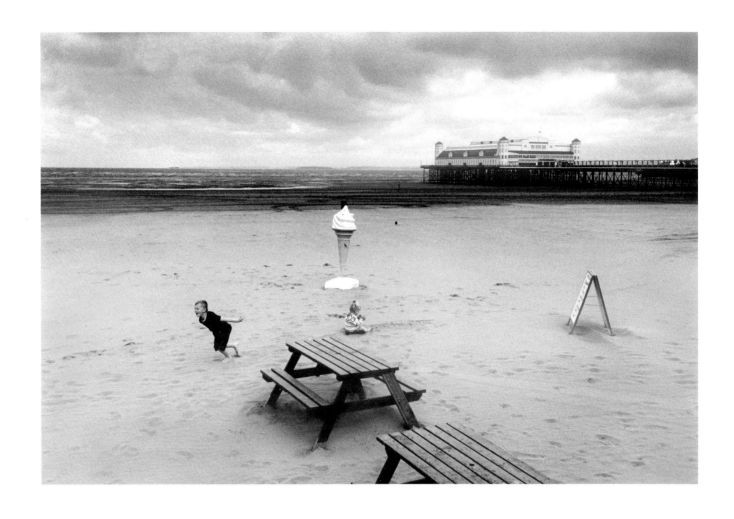

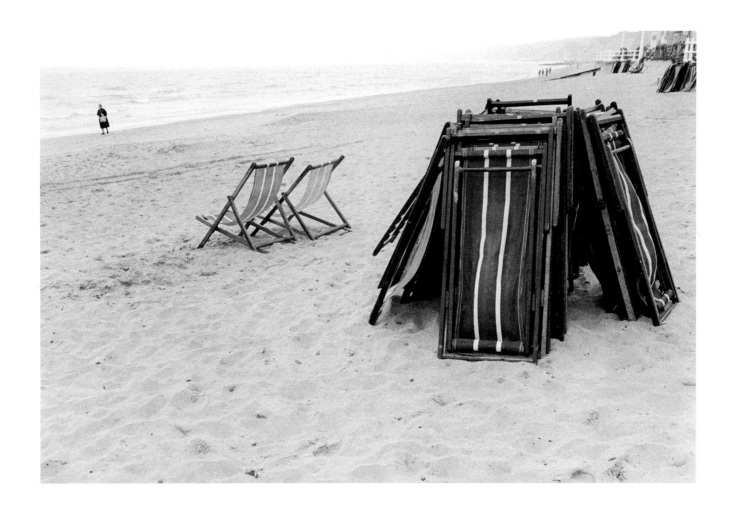

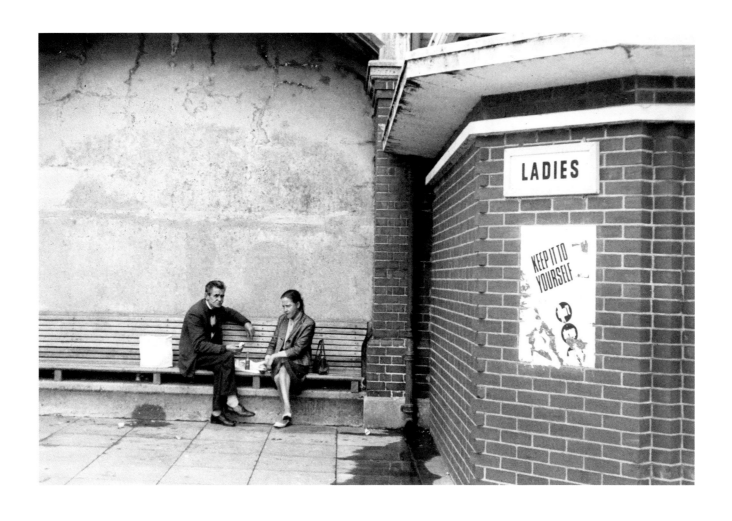

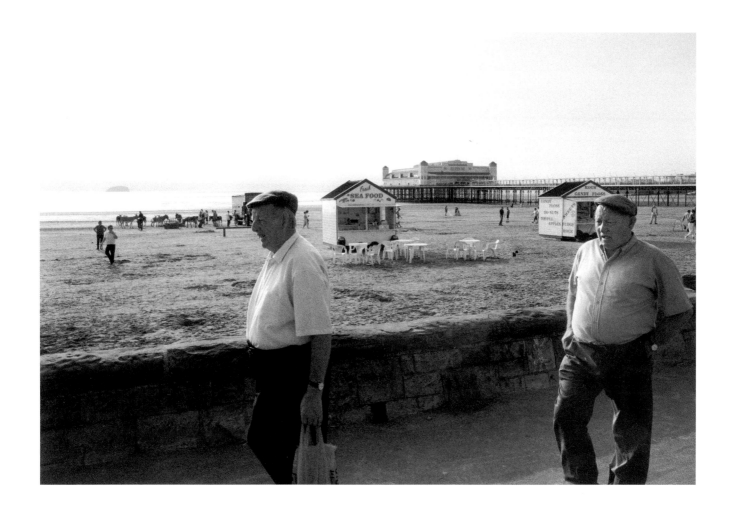

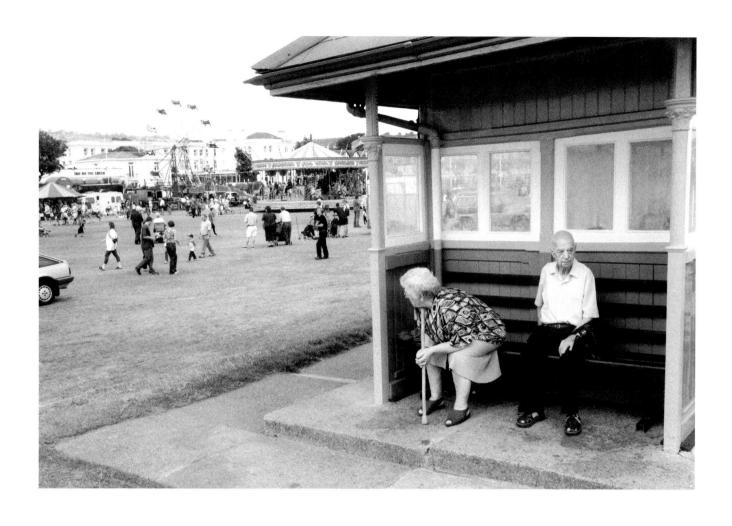

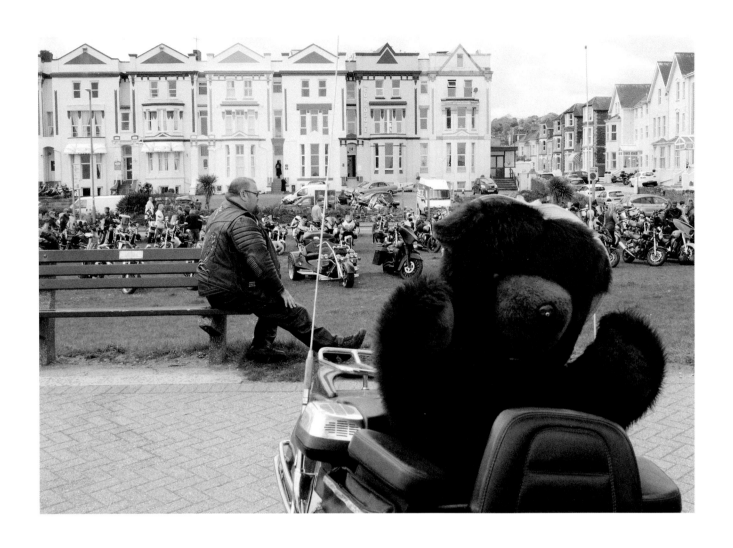

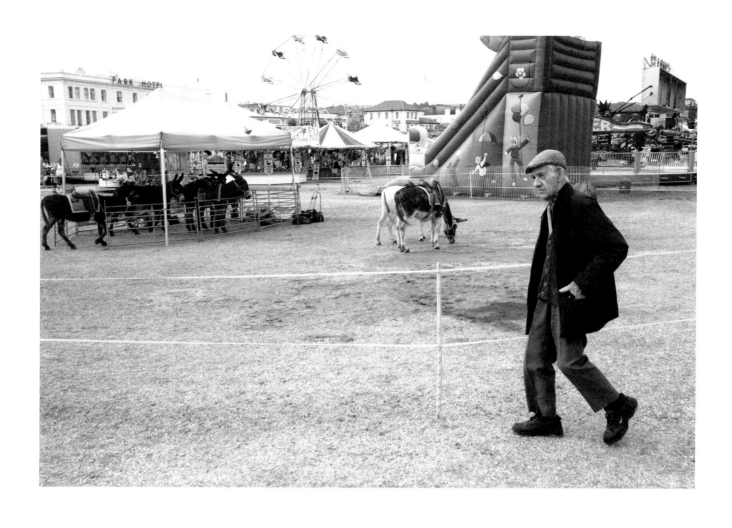

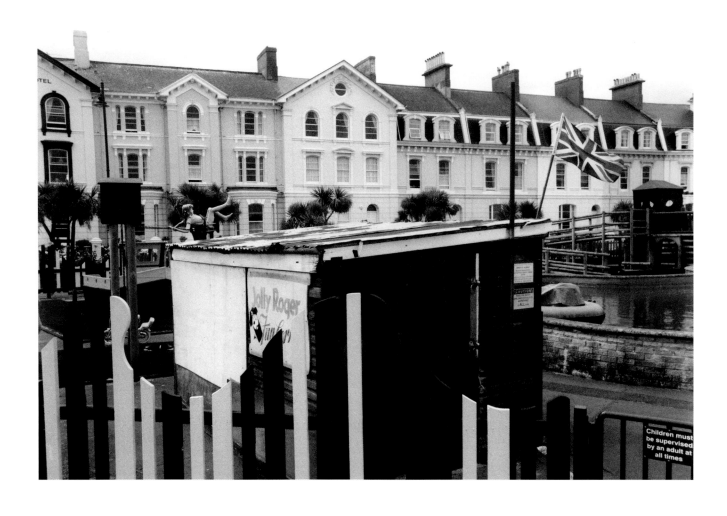

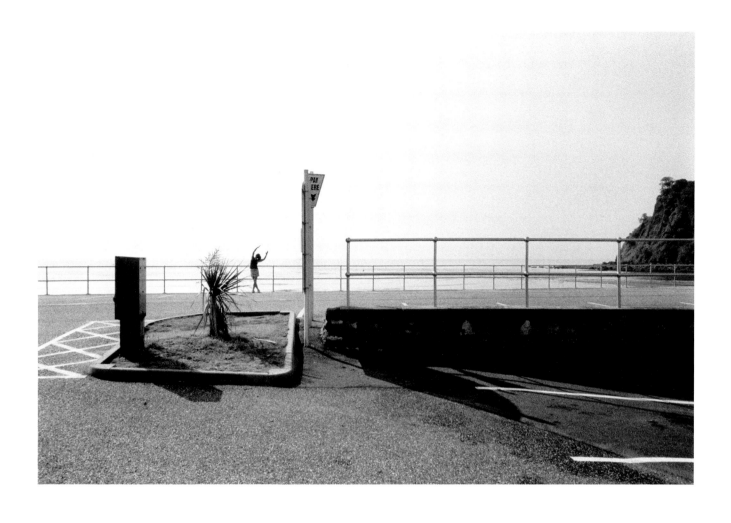

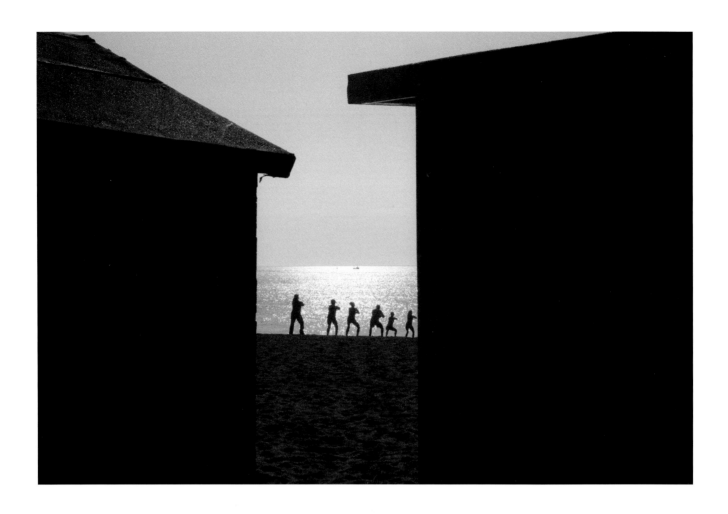

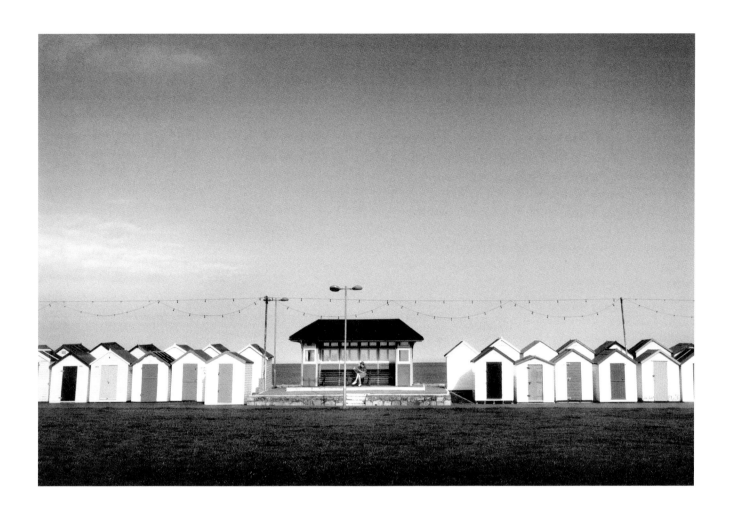

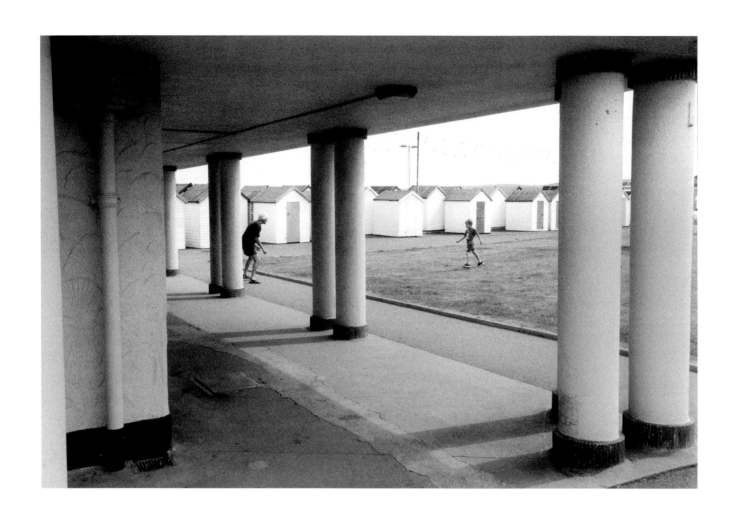

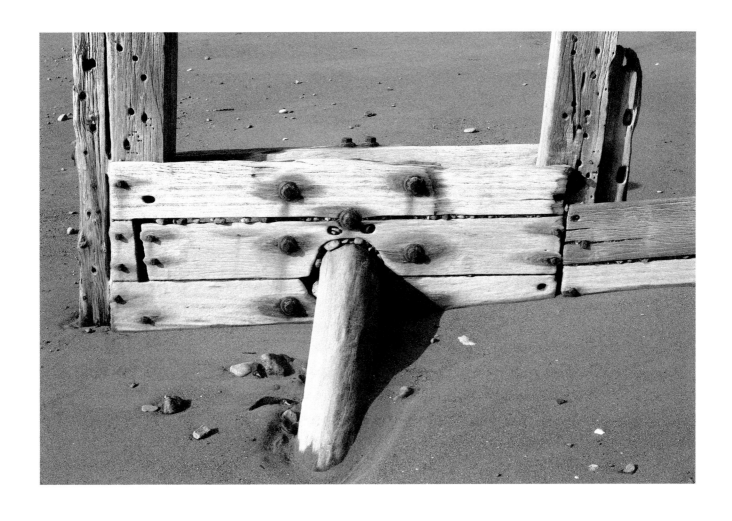

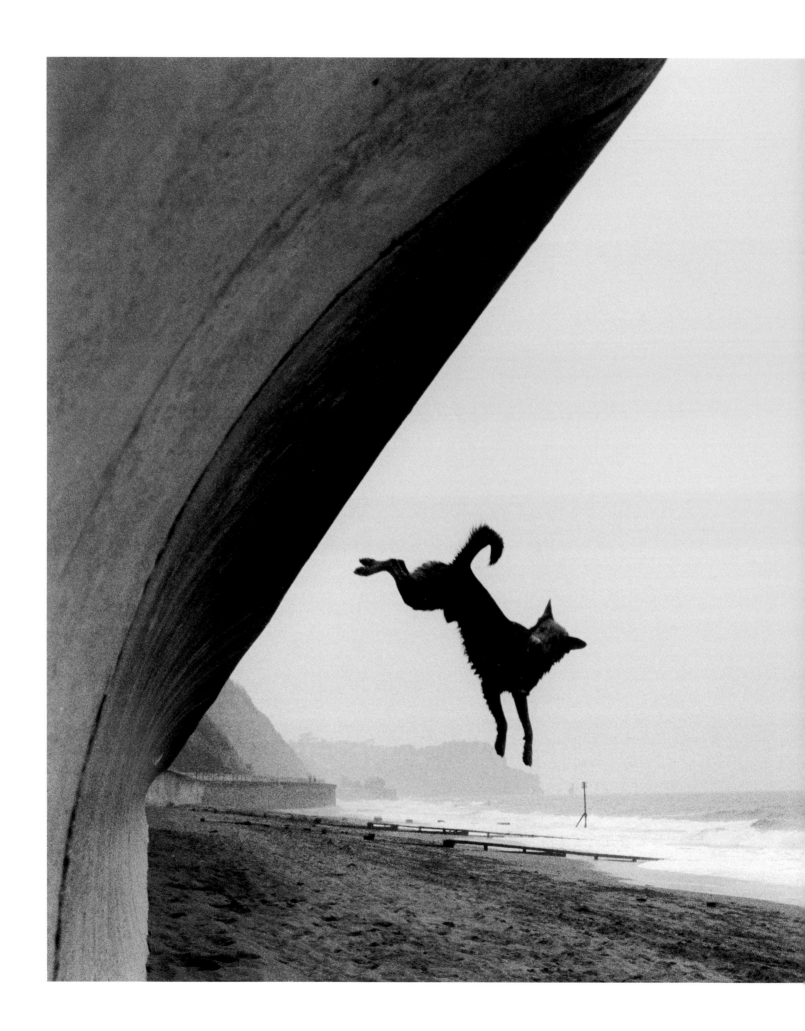

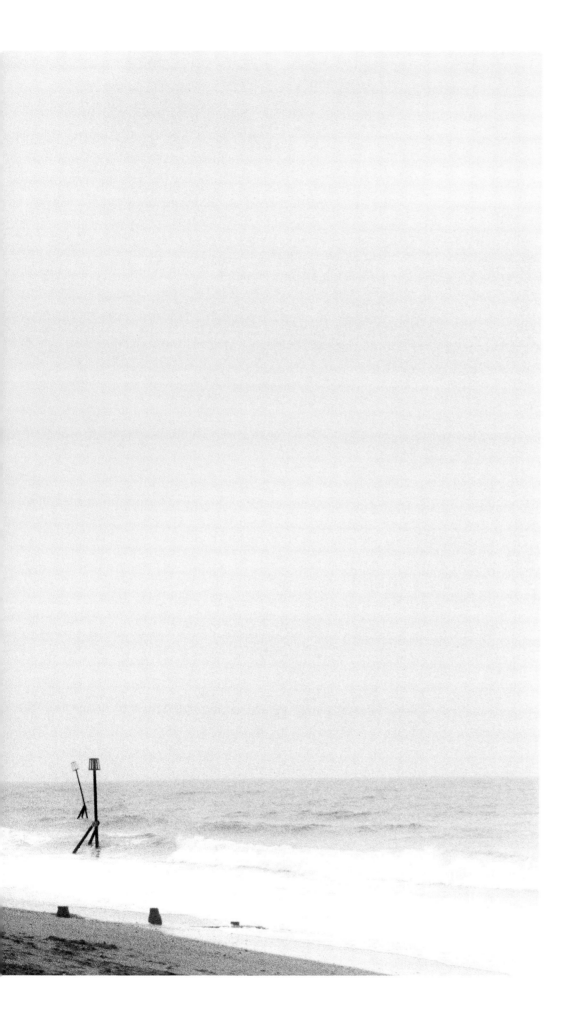

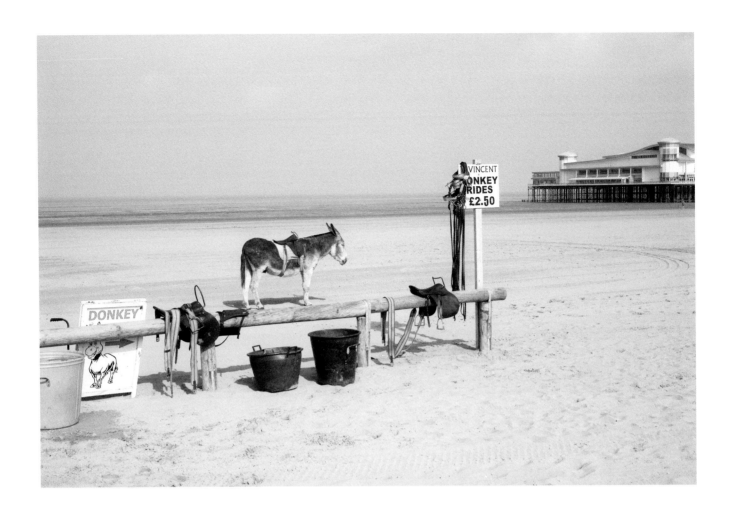

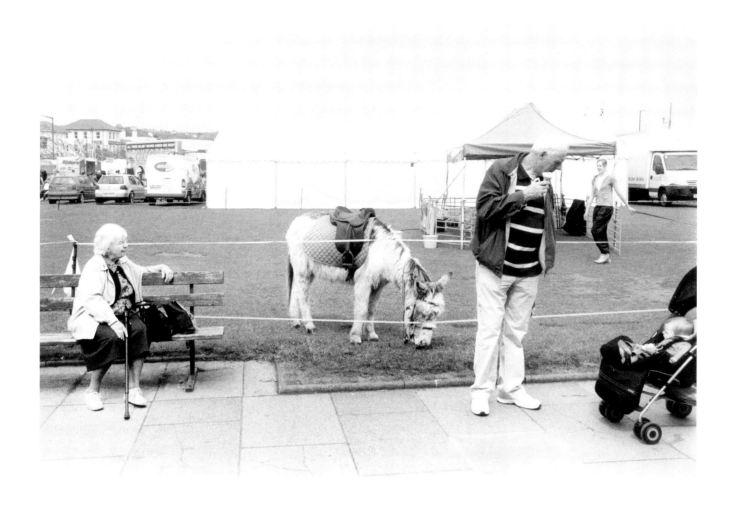

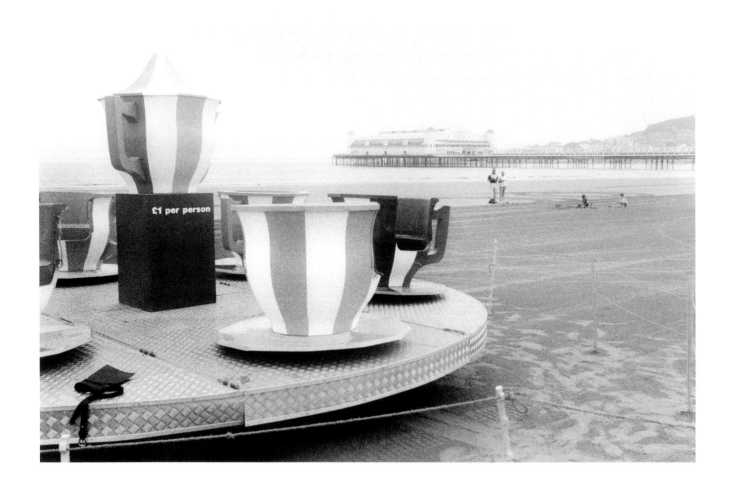

£1 per person

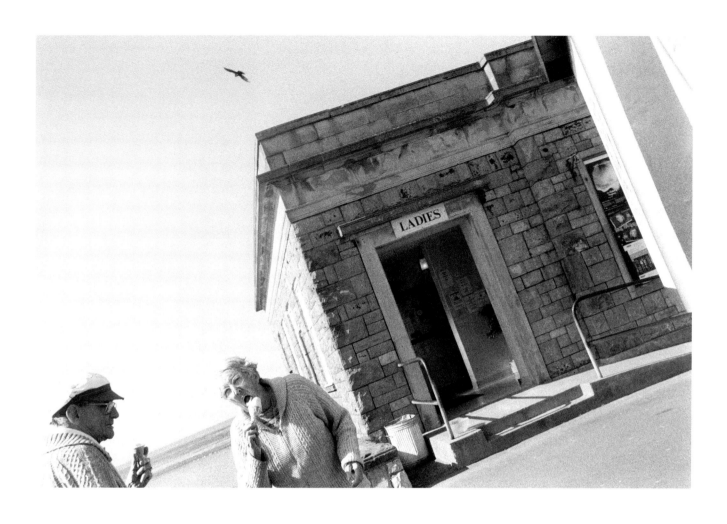

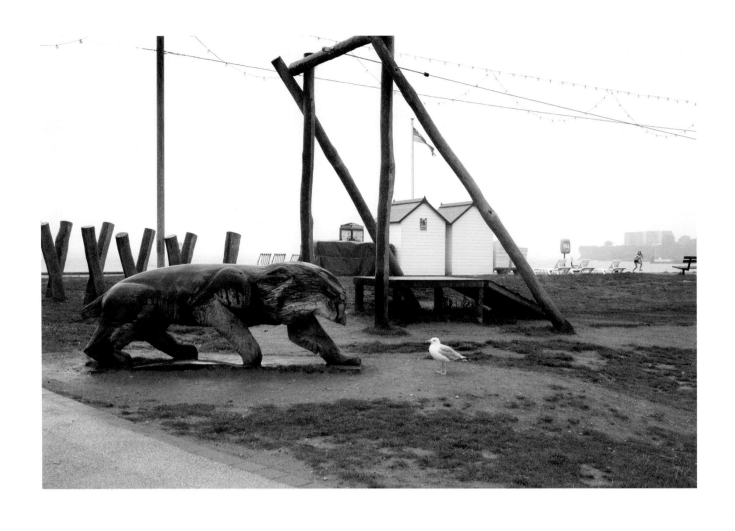

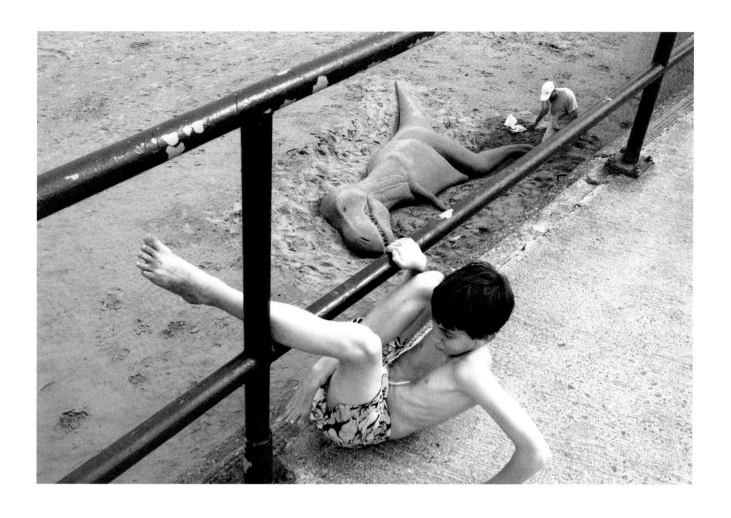

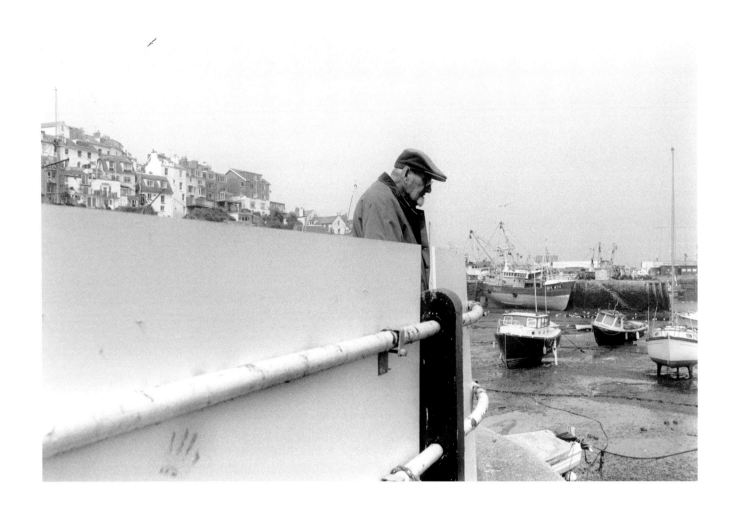

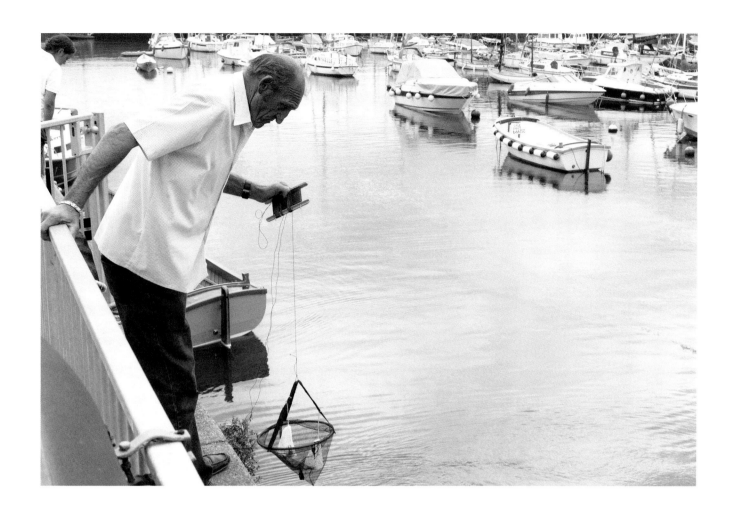

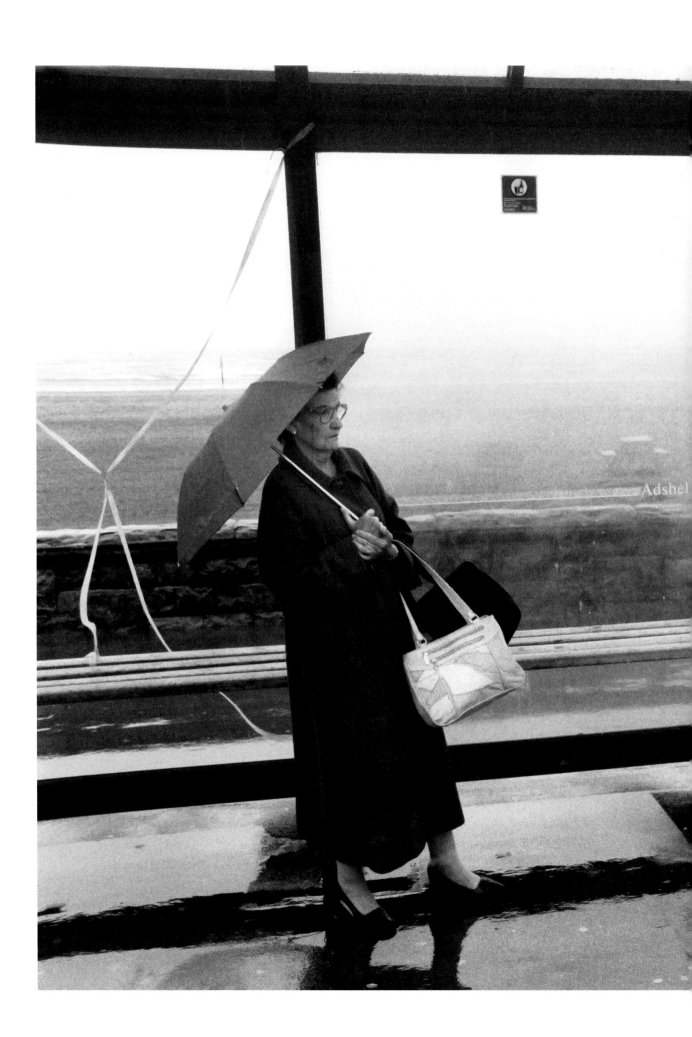

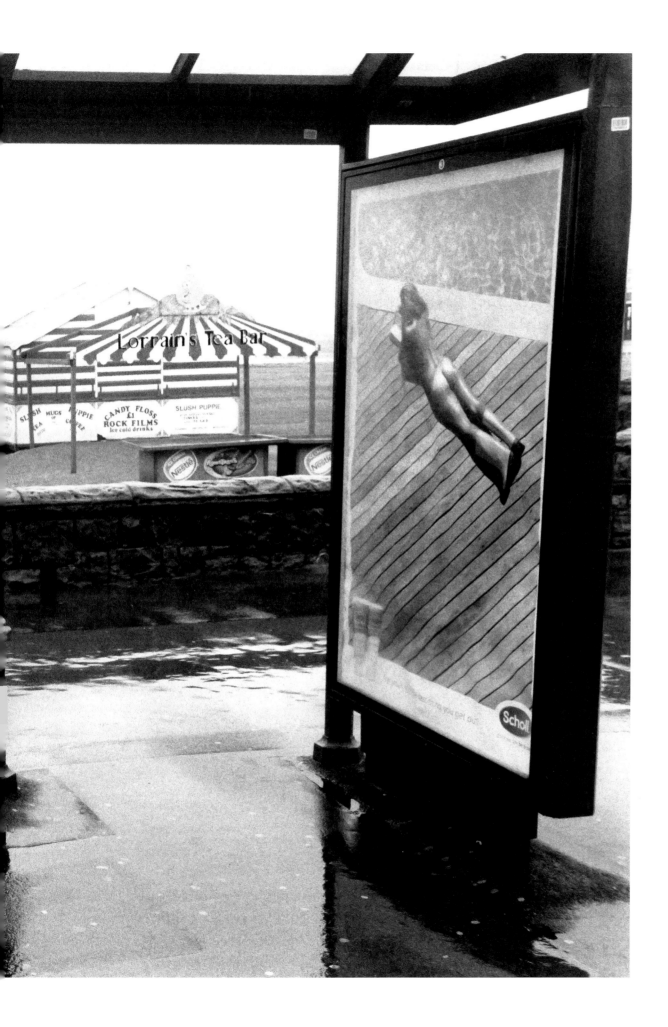

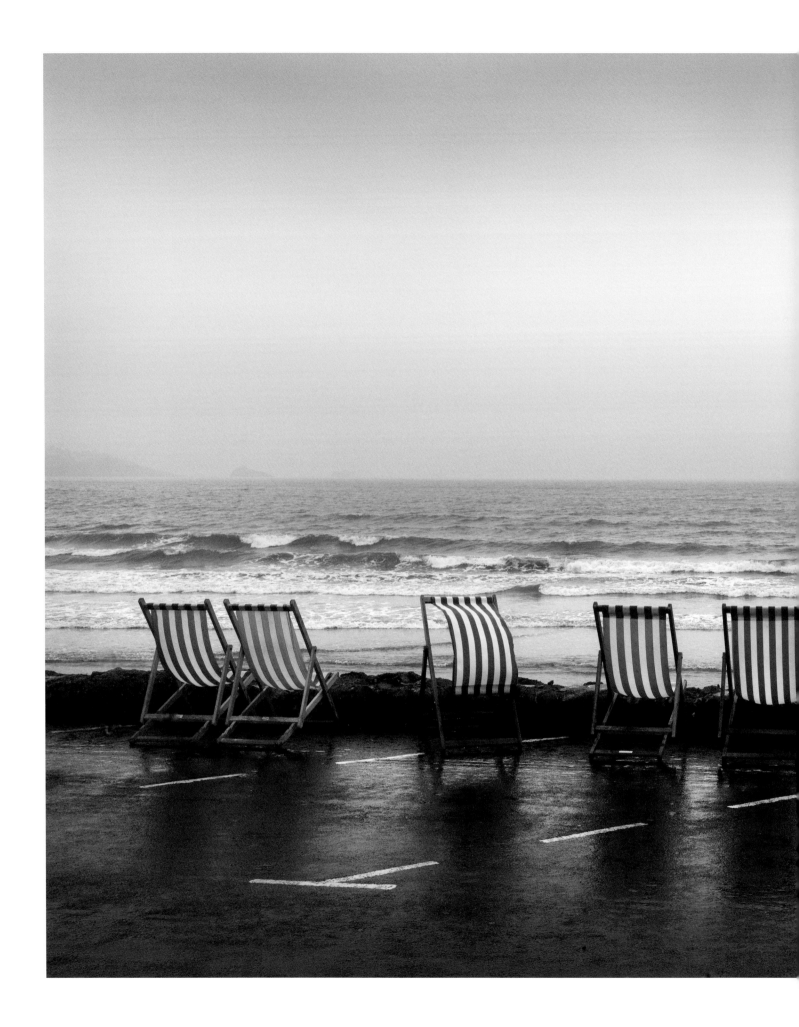

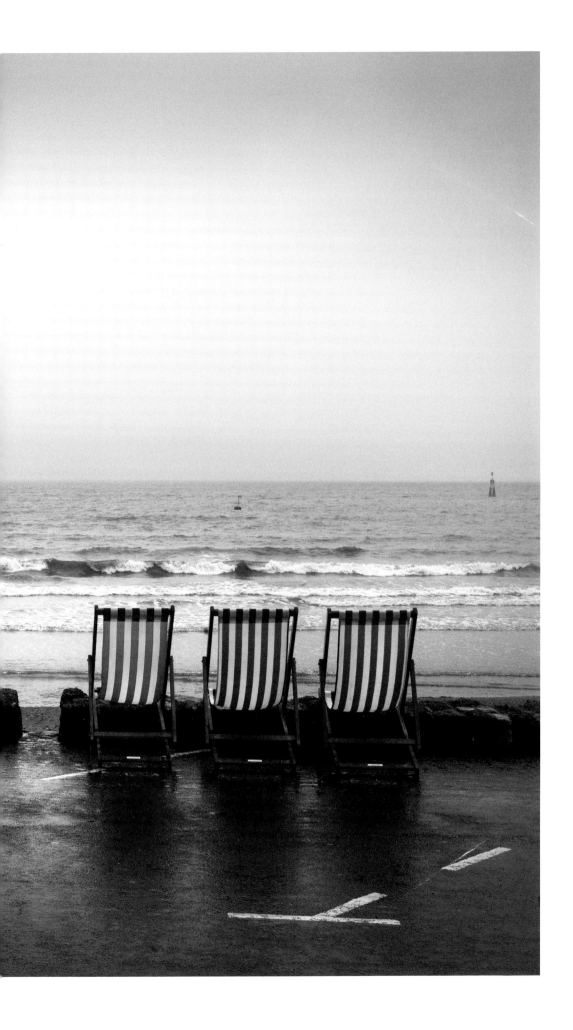

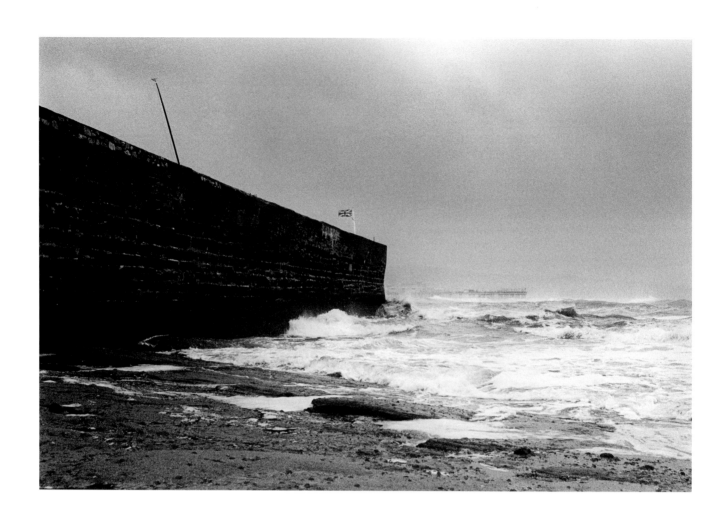

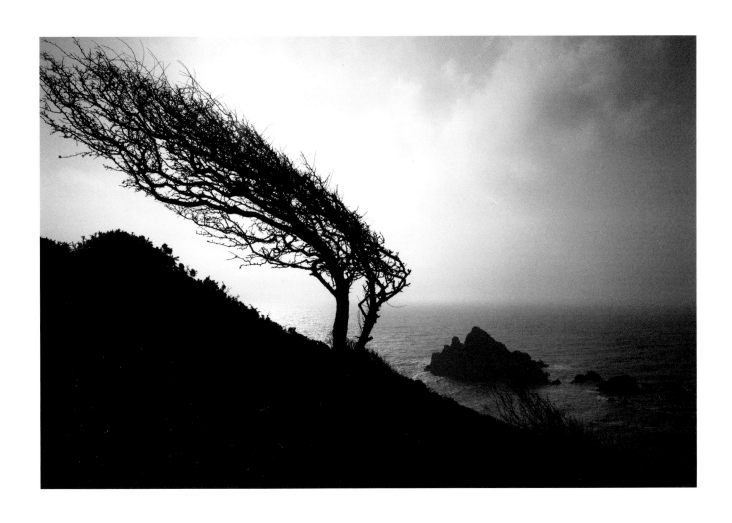

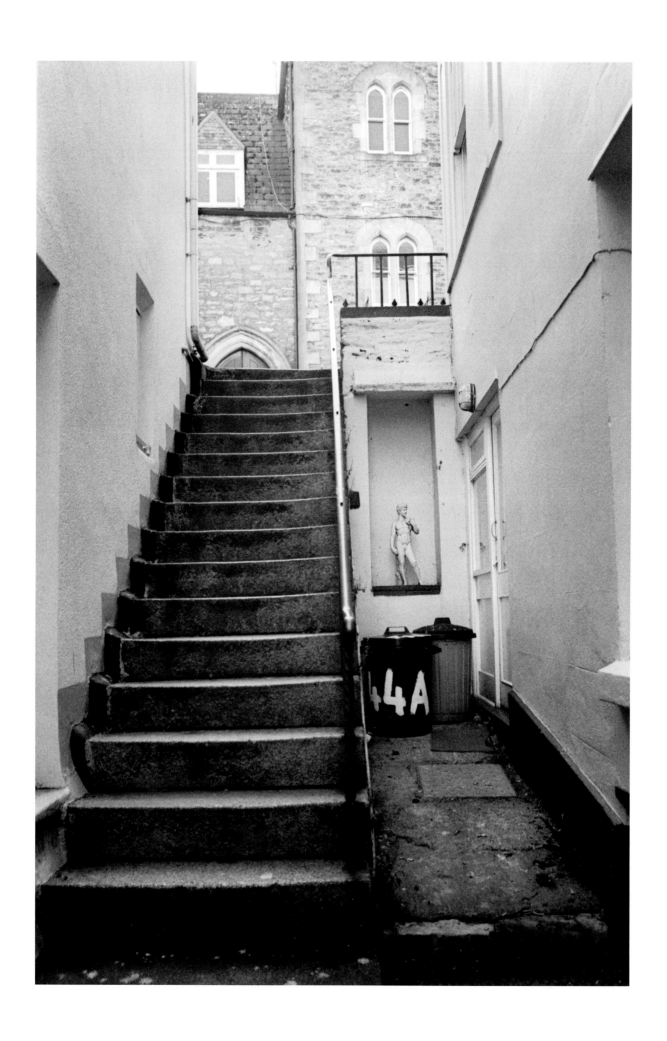

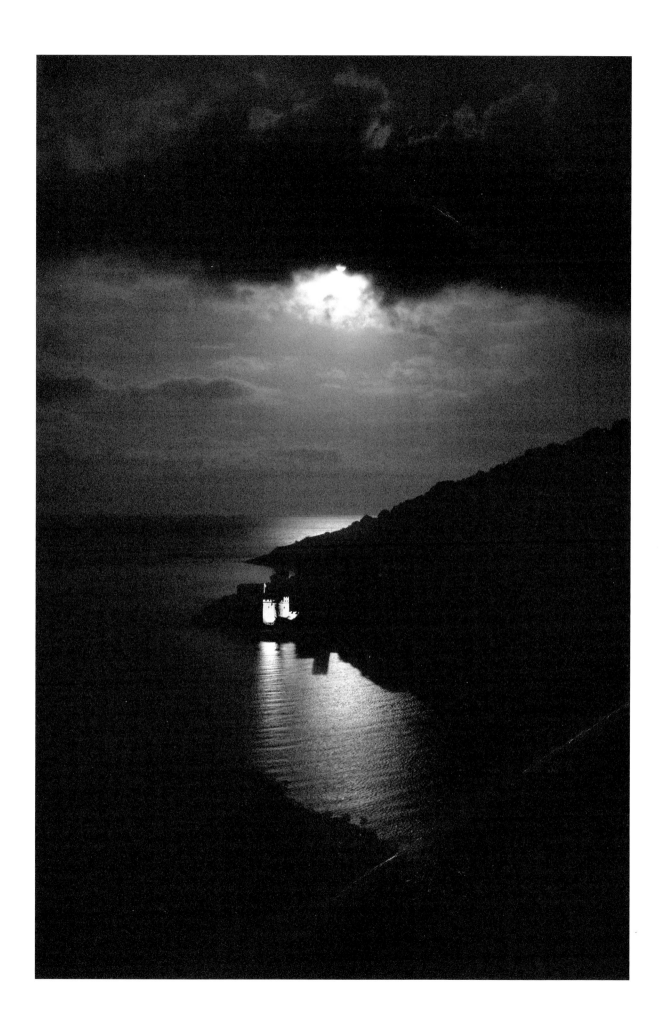

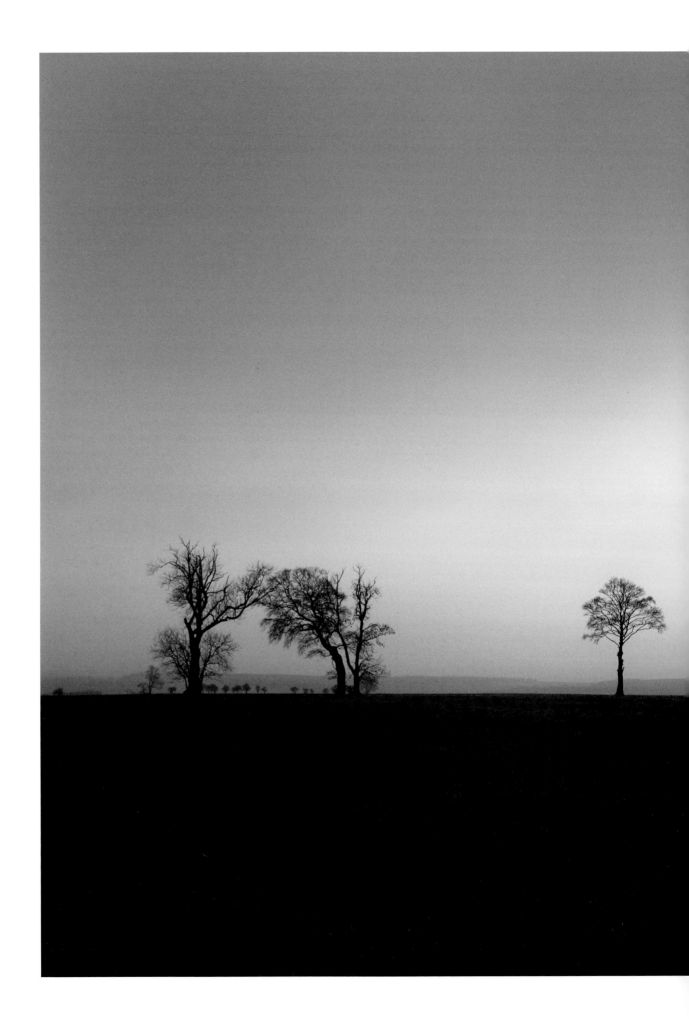

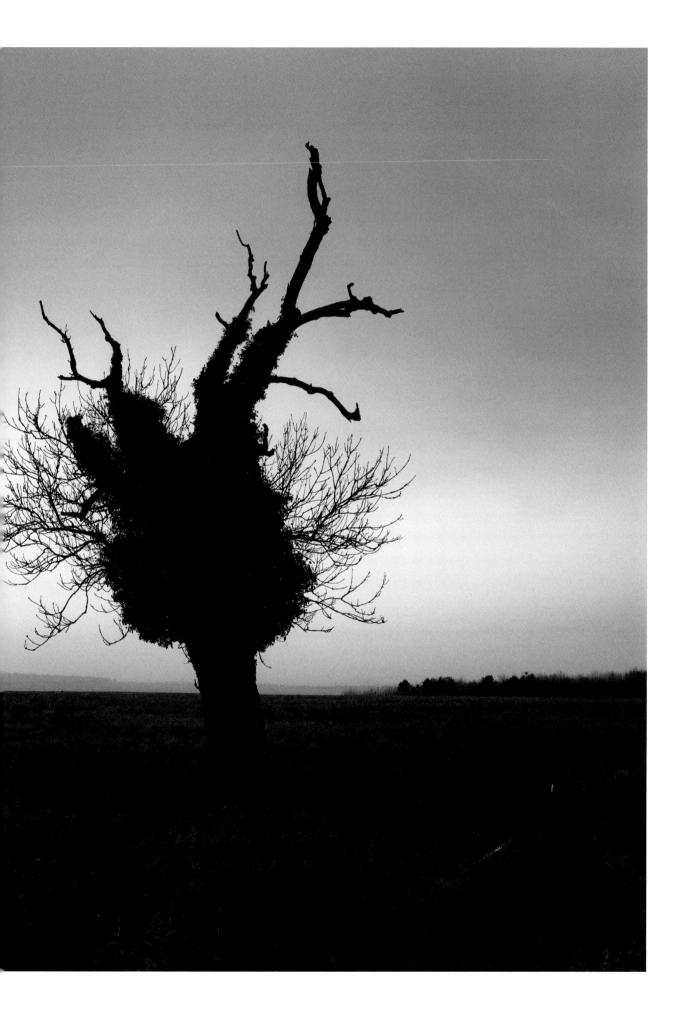

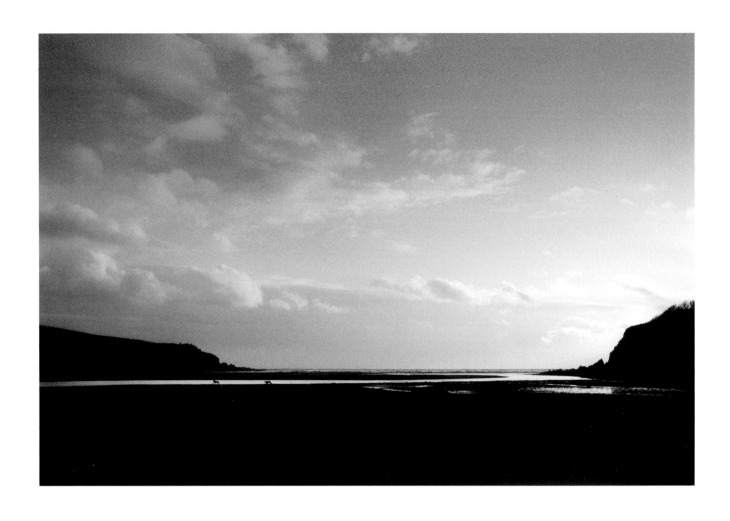

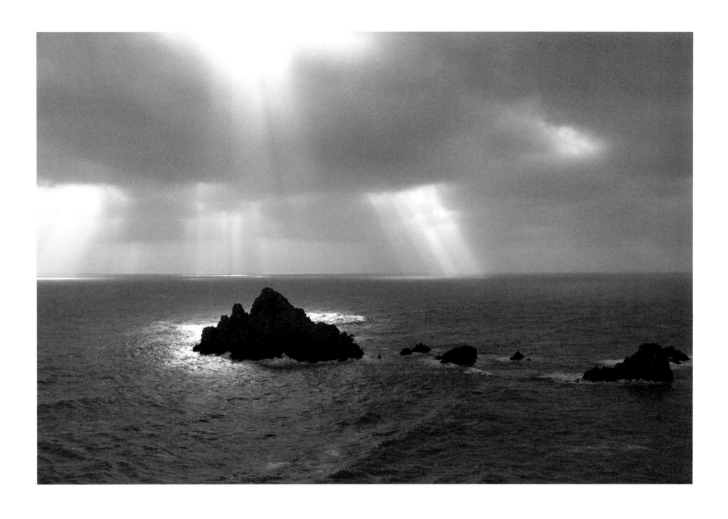

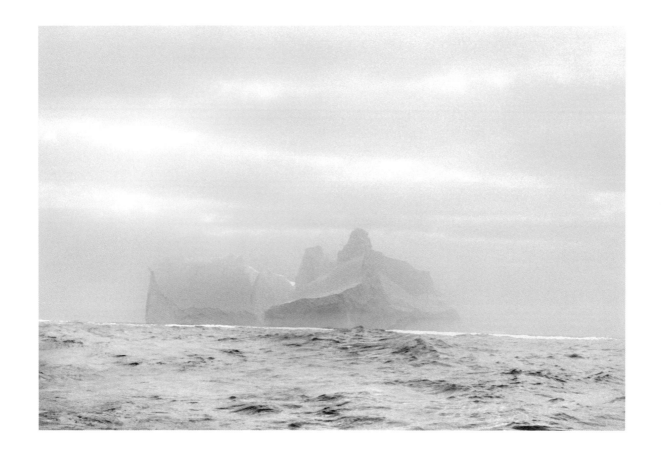

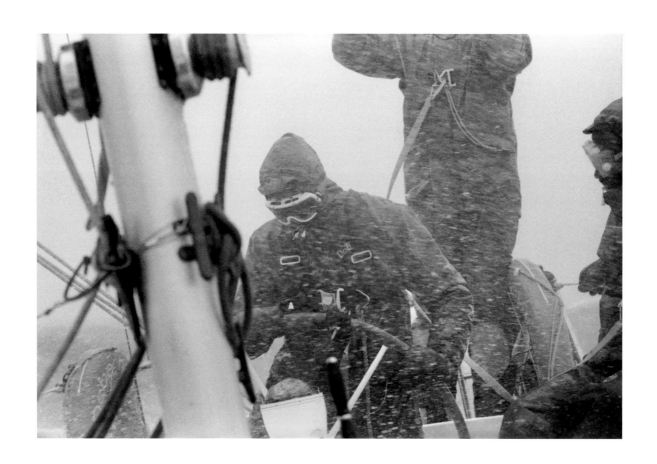

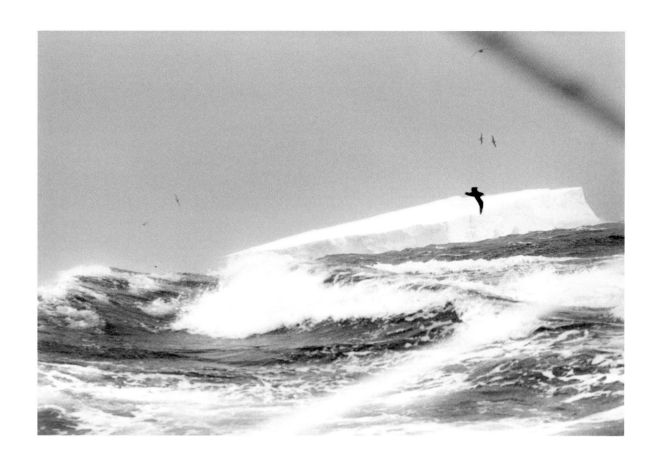

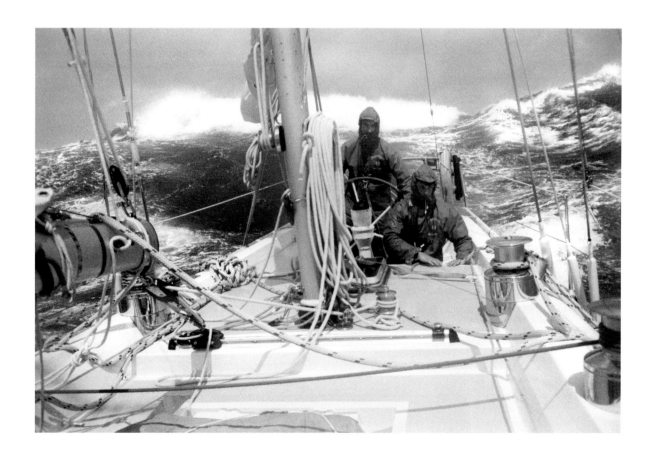

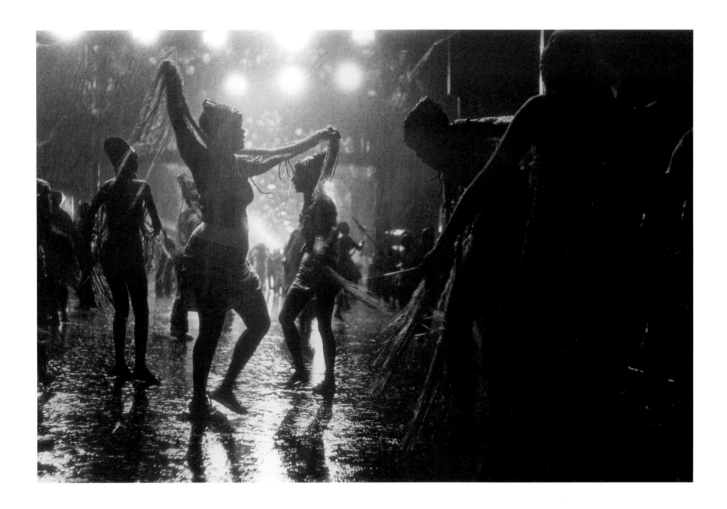

The previous four images were taken during the second edition of the Whitbread Round the World Yacht Race, somewhere in the seemingly endless expanse of the Southern Ocean between the Cape of Good Hope and Cape Horn.

As we rounded 'the Horn', I remembered a favorite speech of captain Ahab, 'But it is a mild, mild wind, and a mild looking sky: and the air smells now, as if it blew from a far-away meadow: they have been making hay somewhere under the slopes of the Andes'. Cut grass produces a very different smell to the salt air at sea and, on that mild day and drinking a toast from a bottle of red wine I had smuggled on board our 'dry' boat for this very purpose, I really could smell the air from that 'far-away meadow'. A few days later our yacht was hit by a fierce storm and we were blown way off course. But, as luck or fate would have it, we docked in Rio de Janeiro on the afternoon of the 4th of February, the first day of the annual street carnival, which, in 1978, was long before it became a ticketed event.

It had been six months since the start of the race in Portsmouth and we had now only the Atlantic Ocean between us and the end of our 27,000-mile journey.

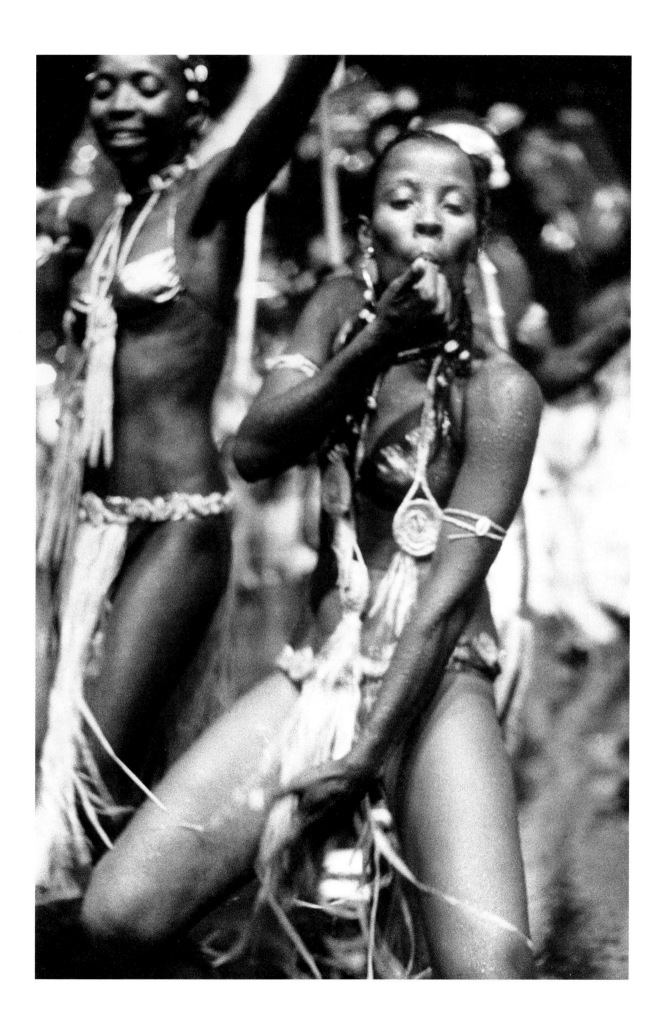

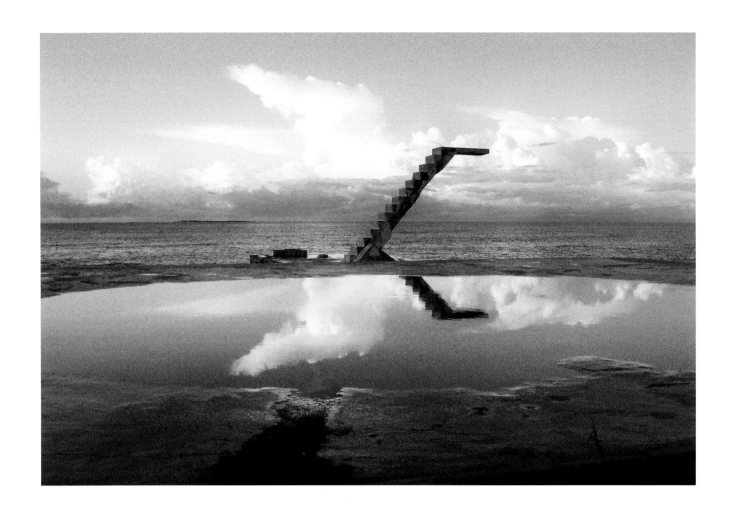

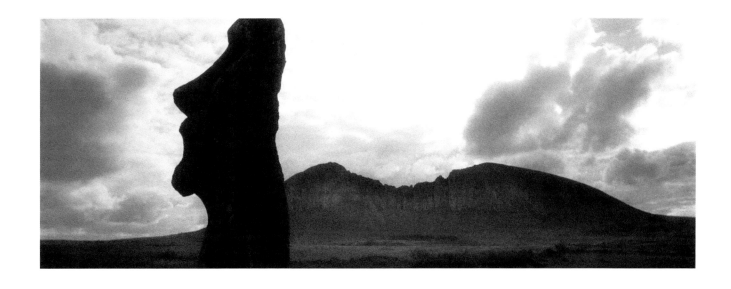

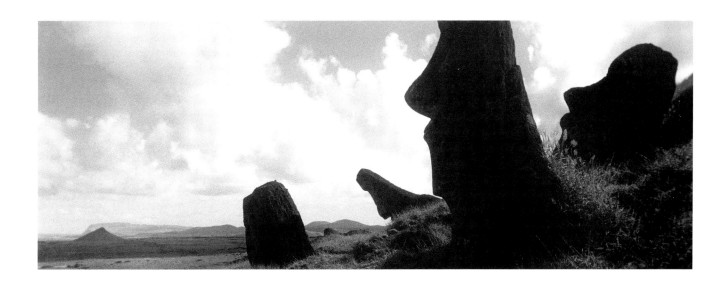

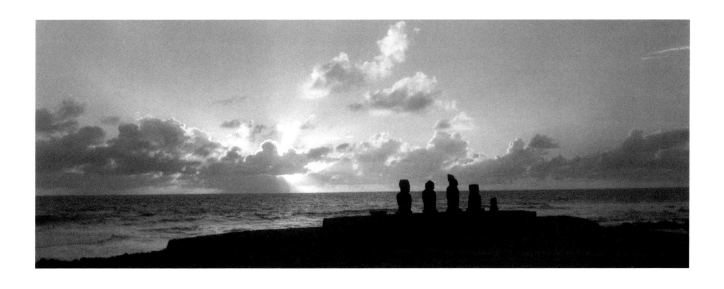

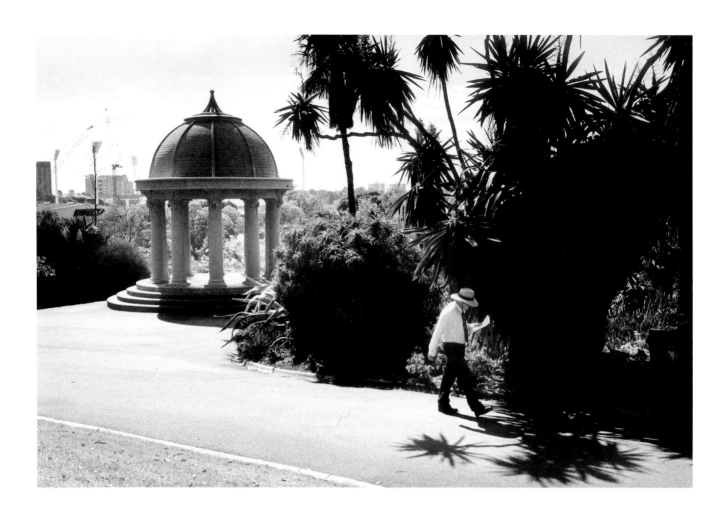

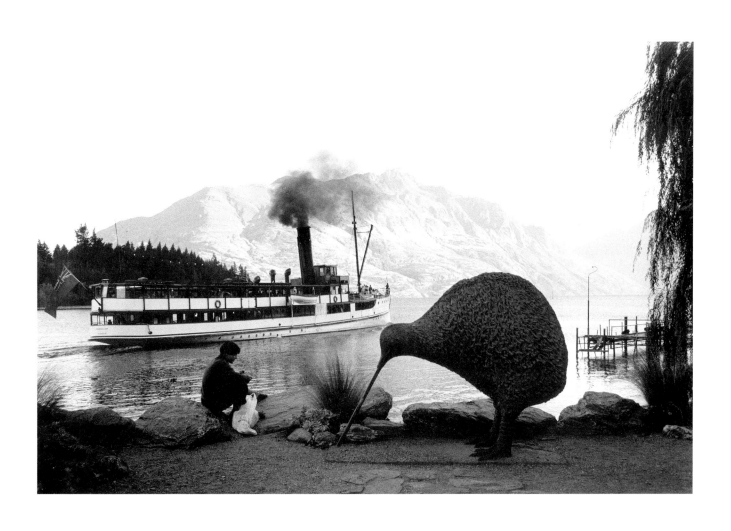

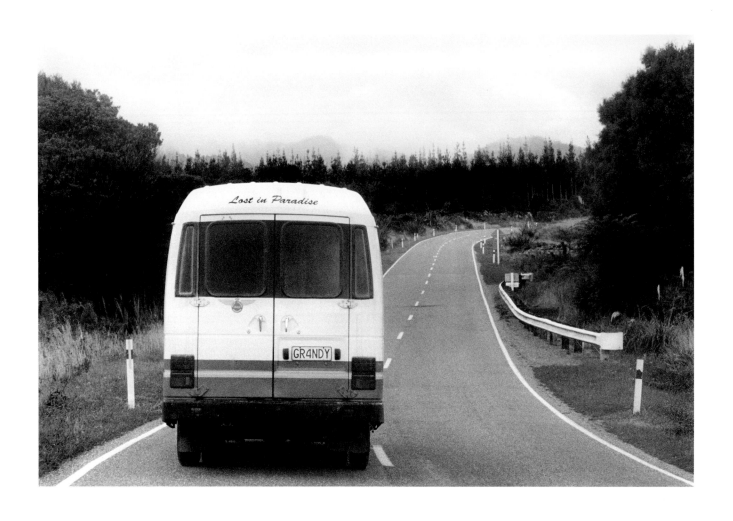

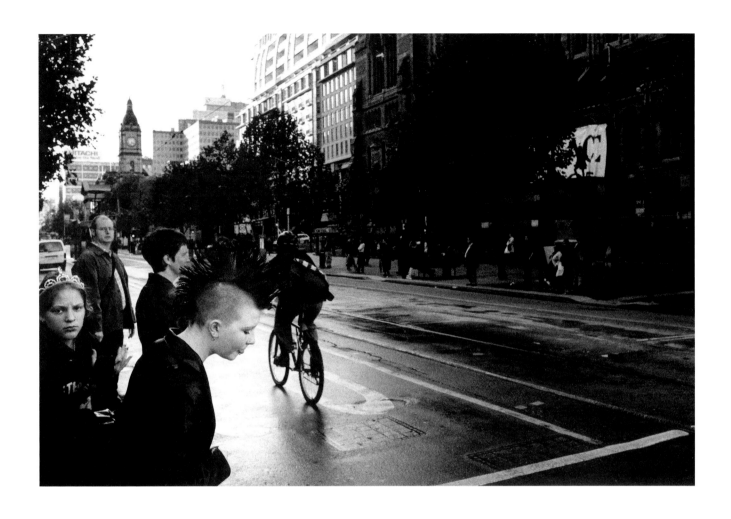

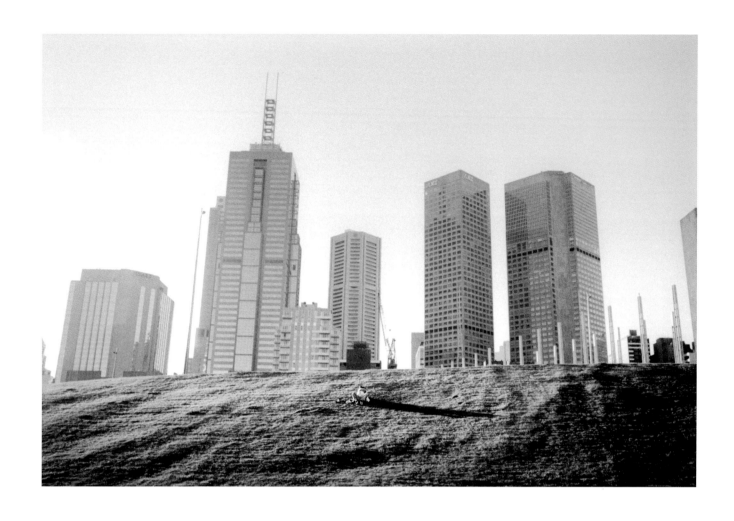

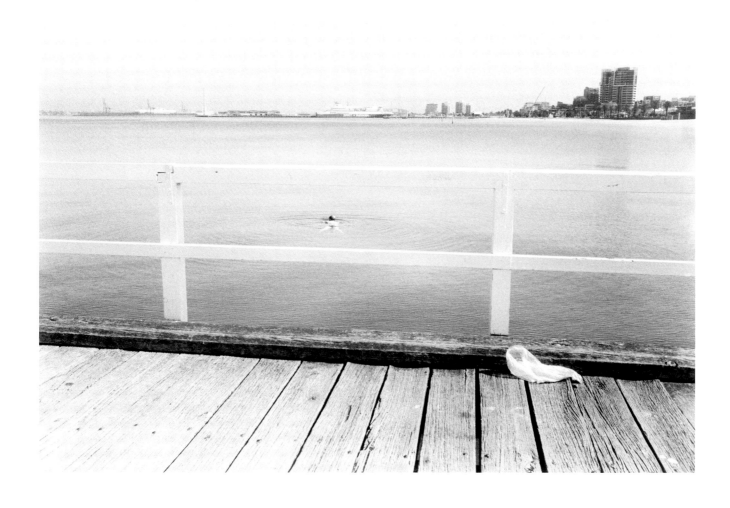

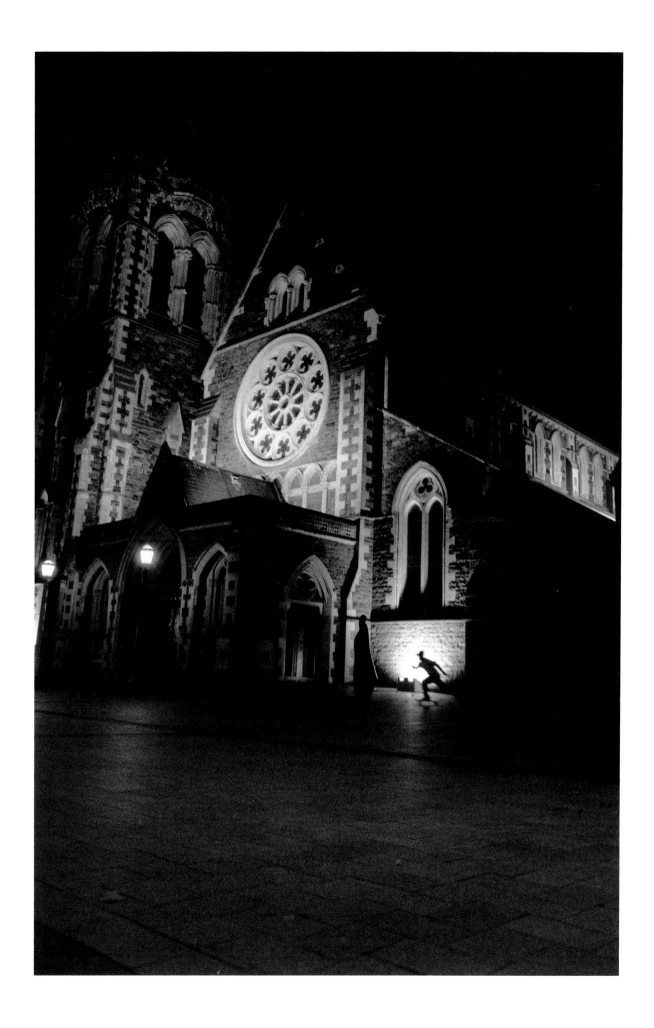

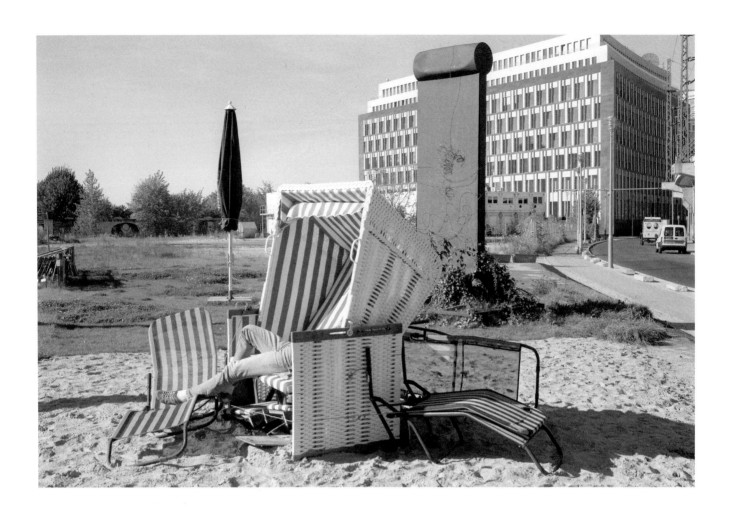

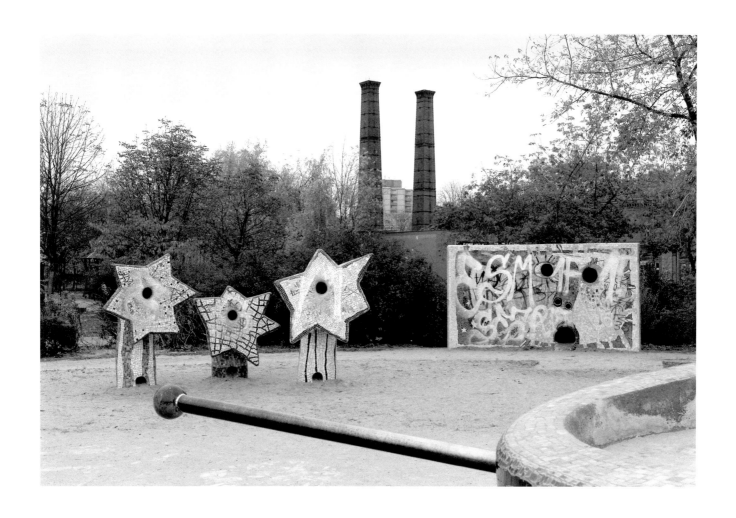

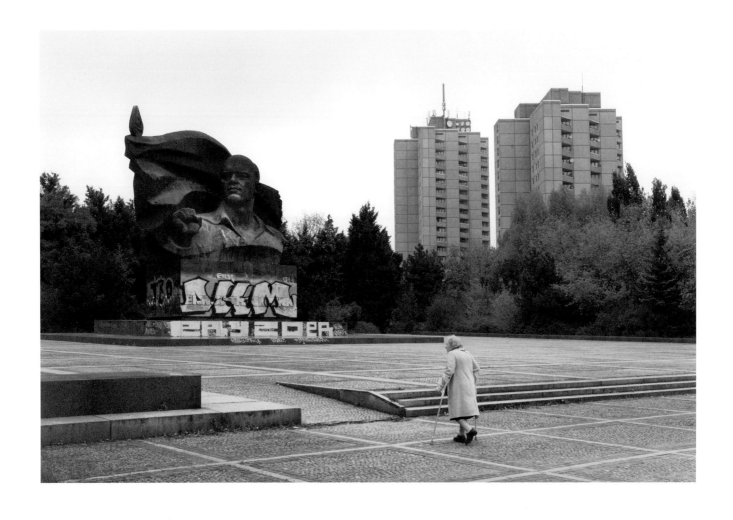

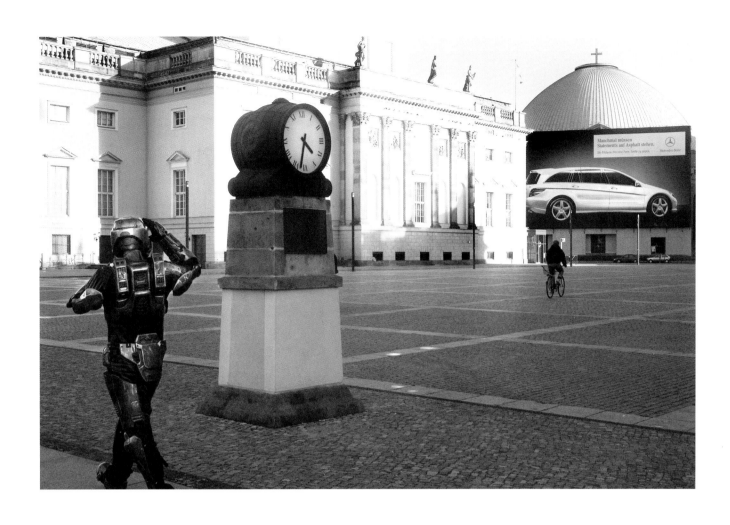

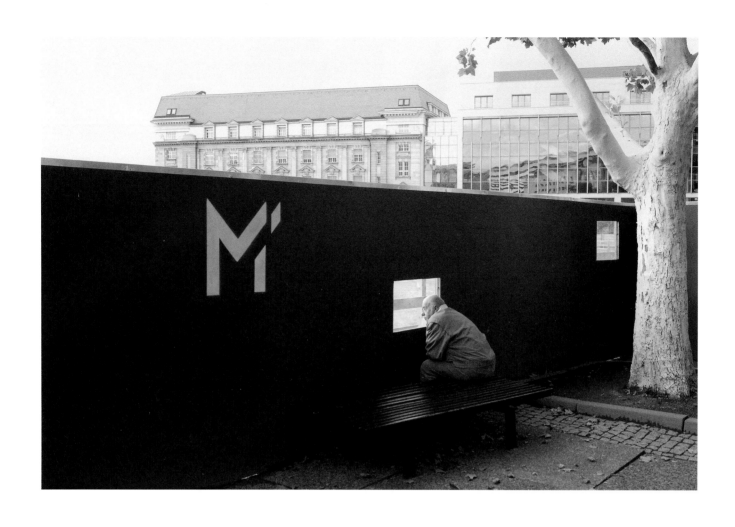

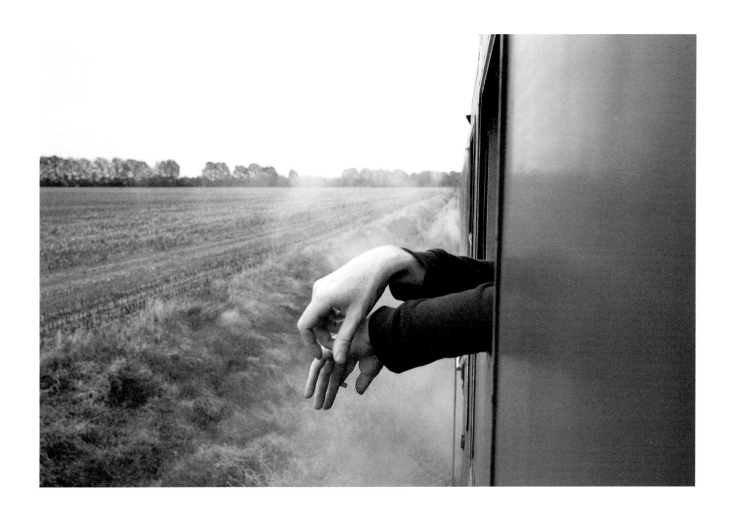

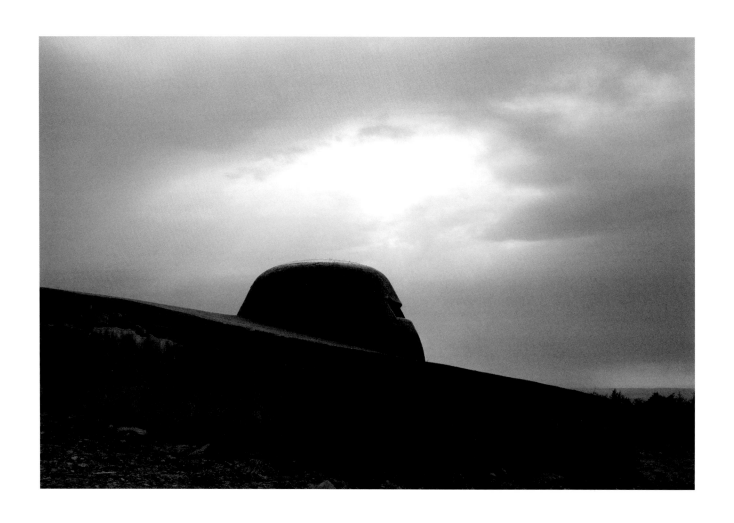

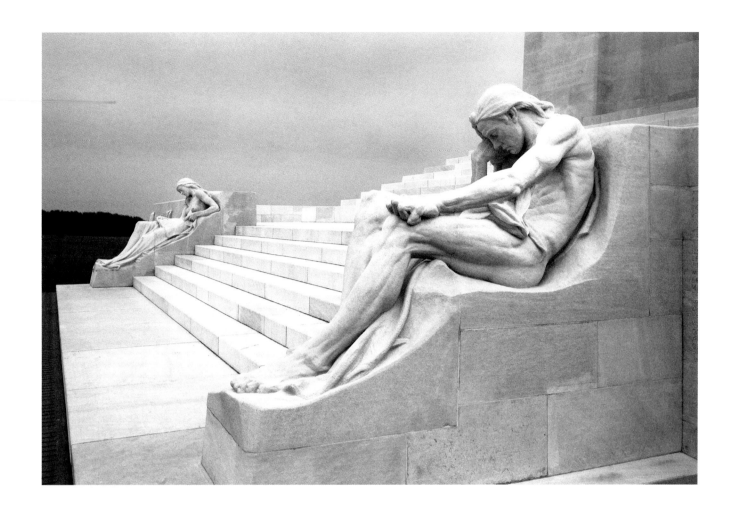

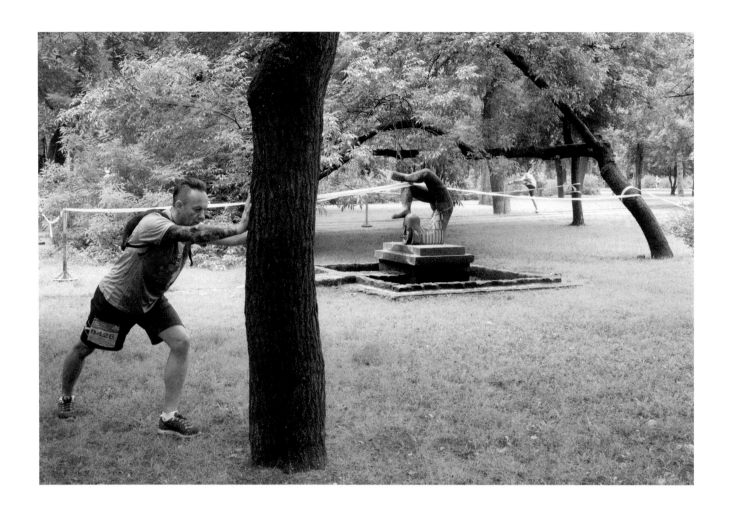

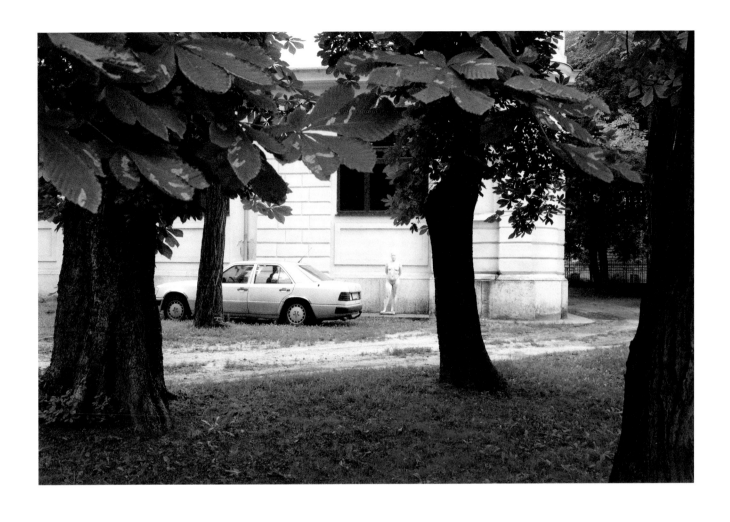

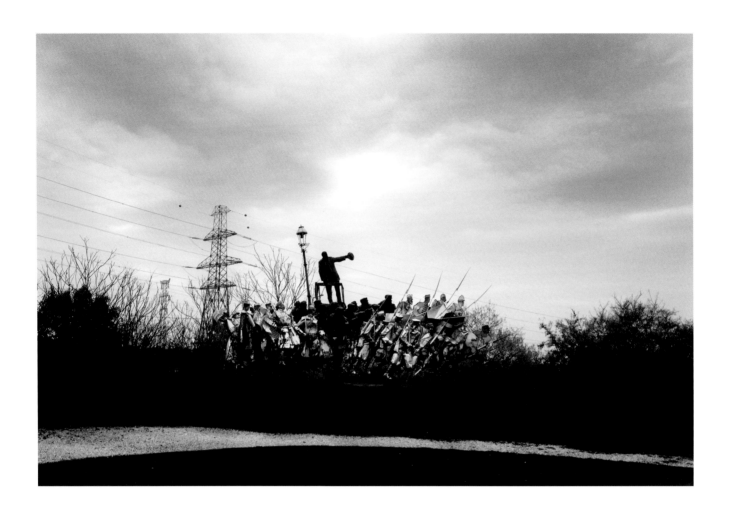

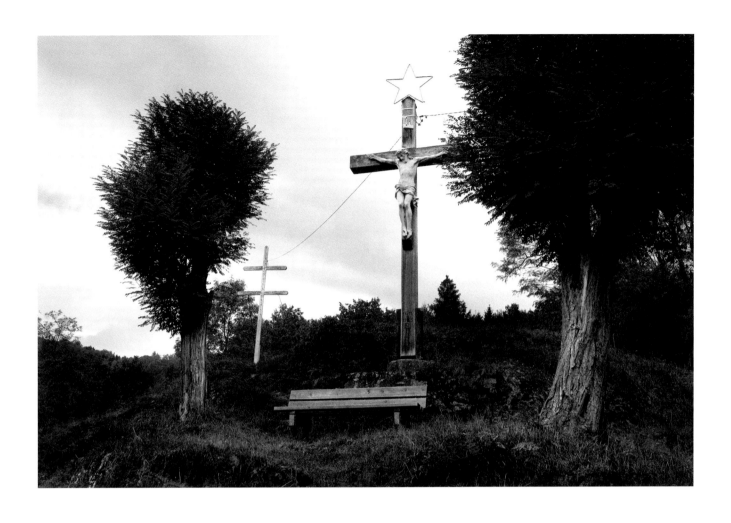

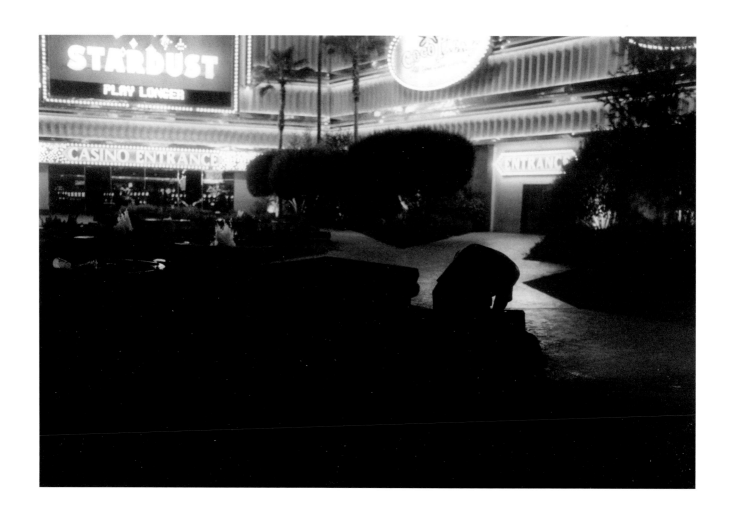

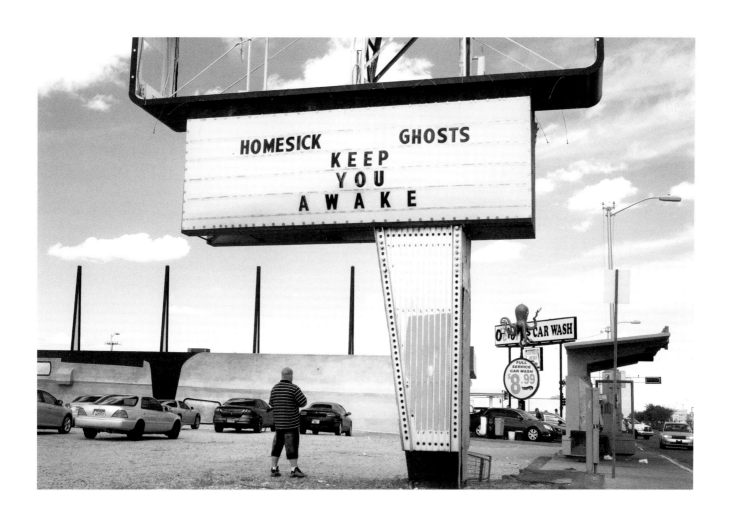

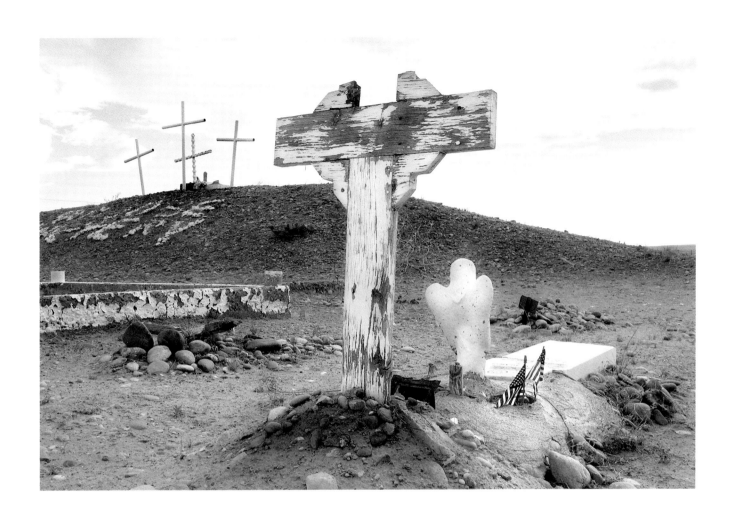

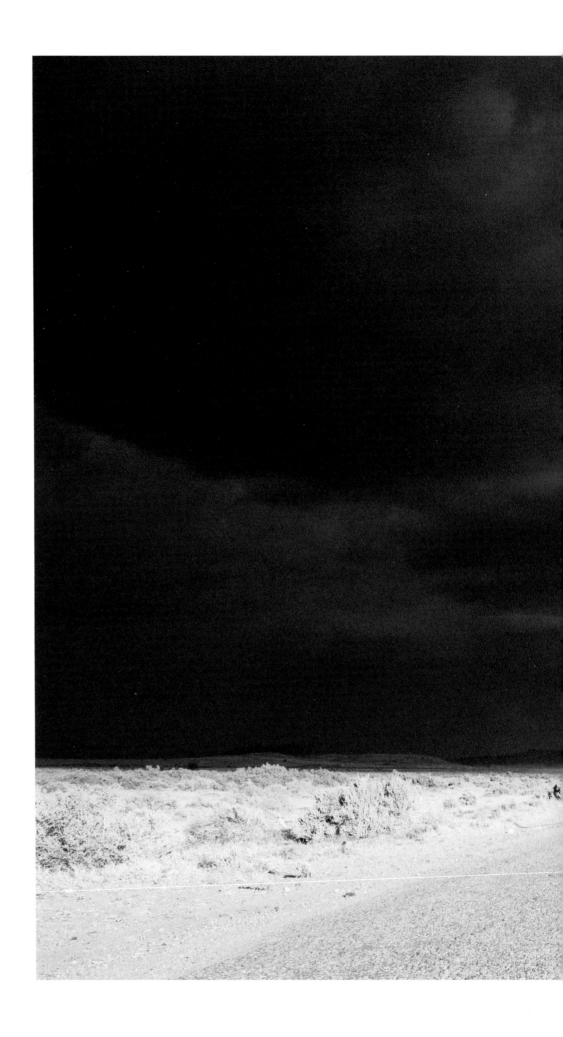

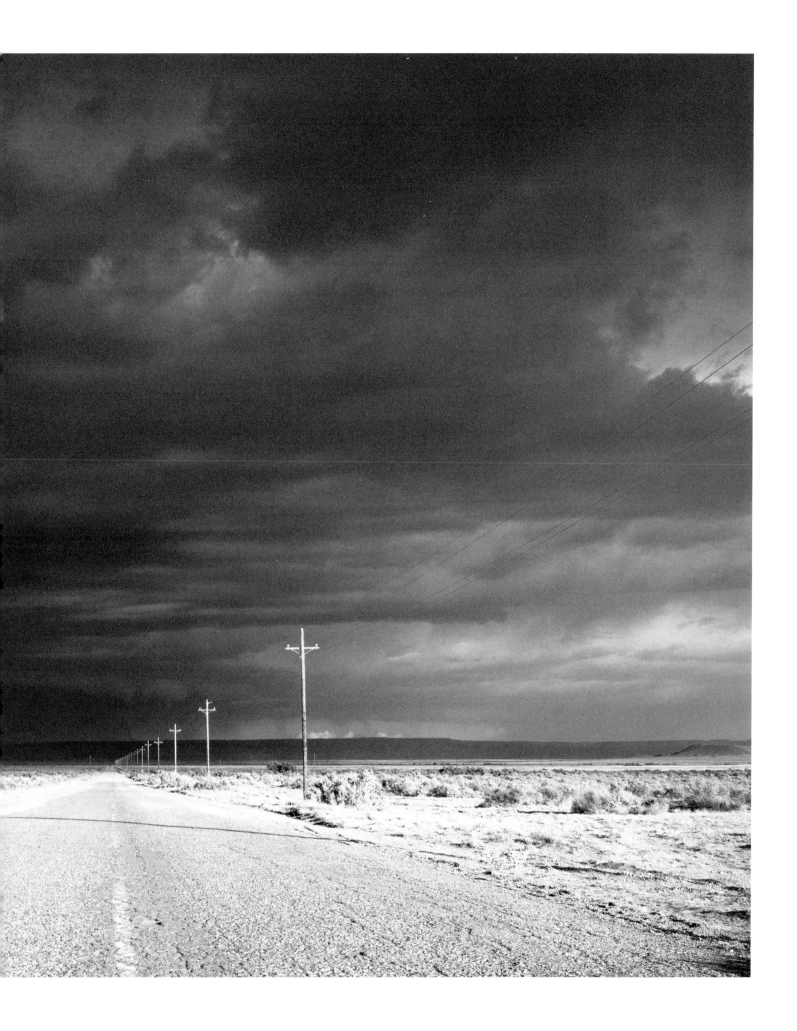

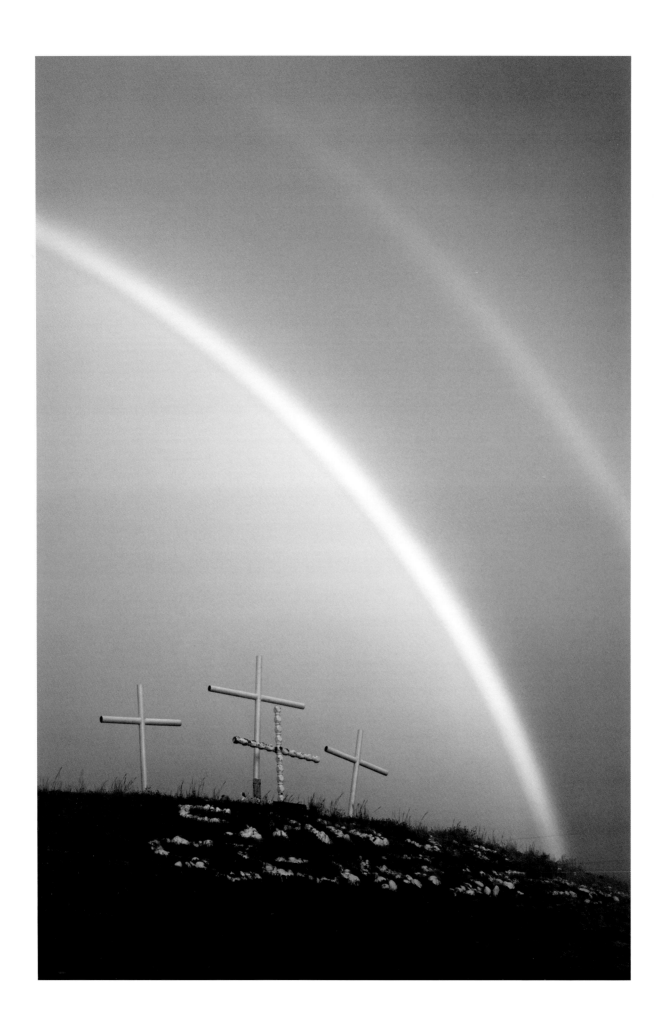

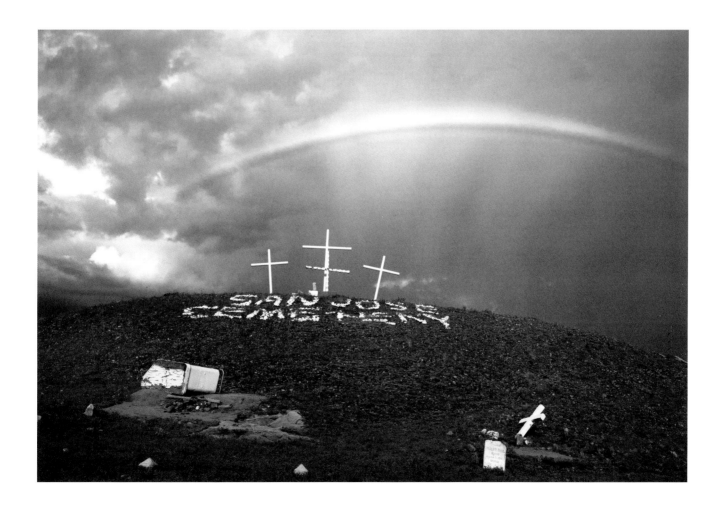

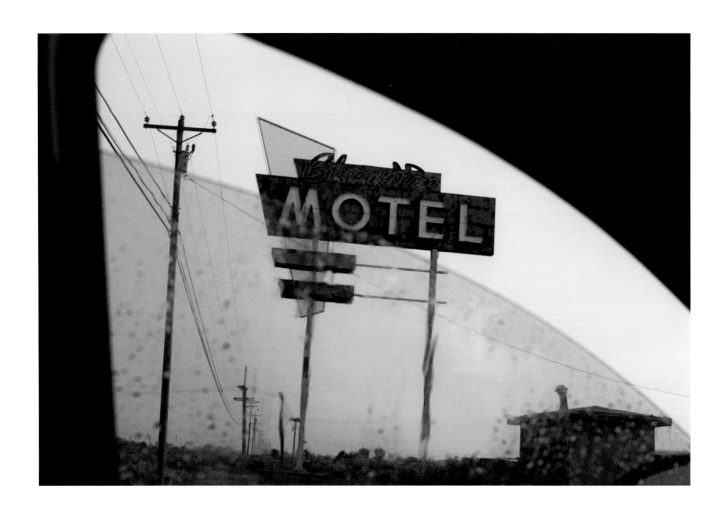

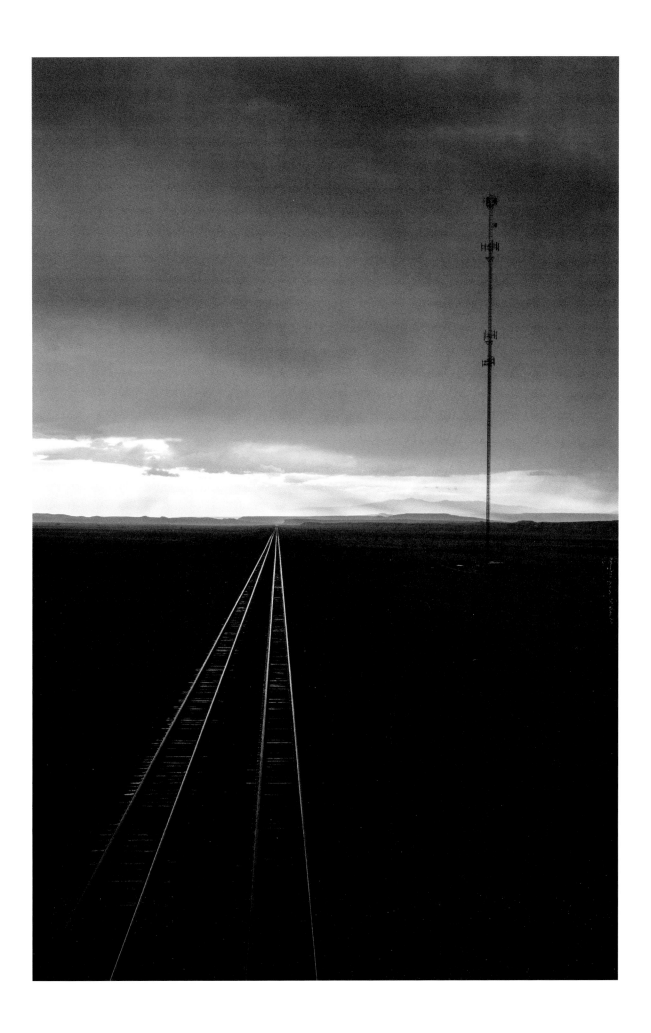

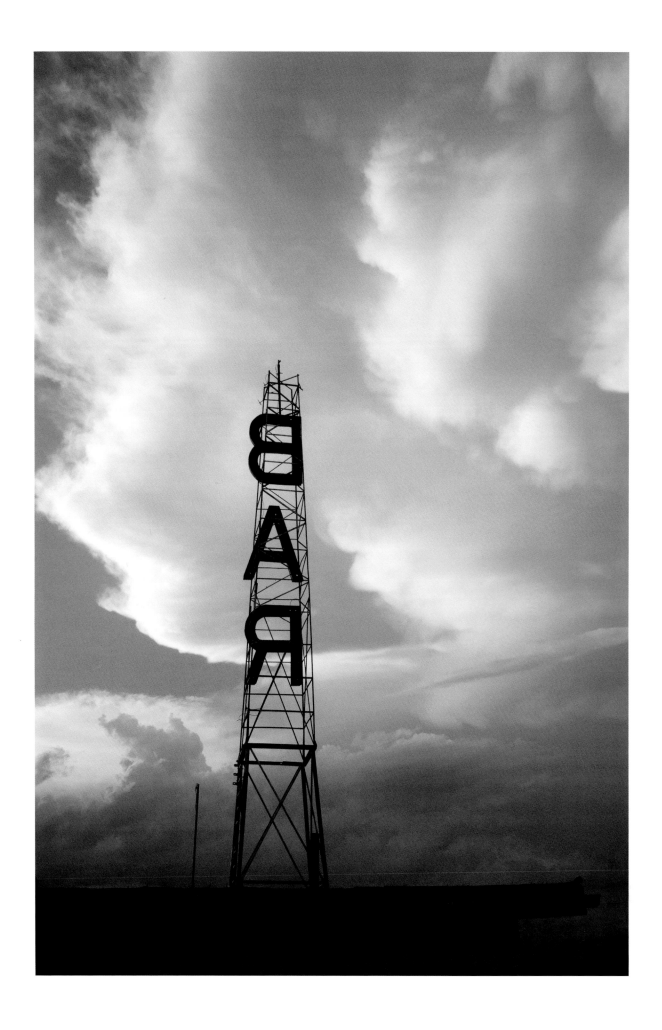

130

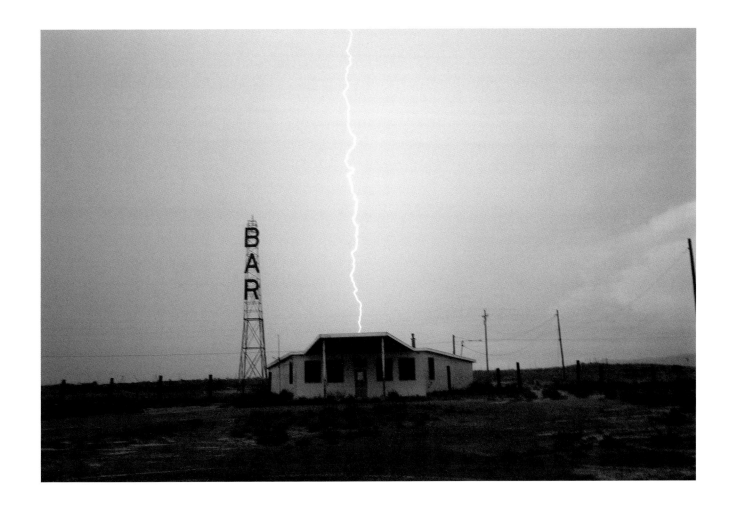

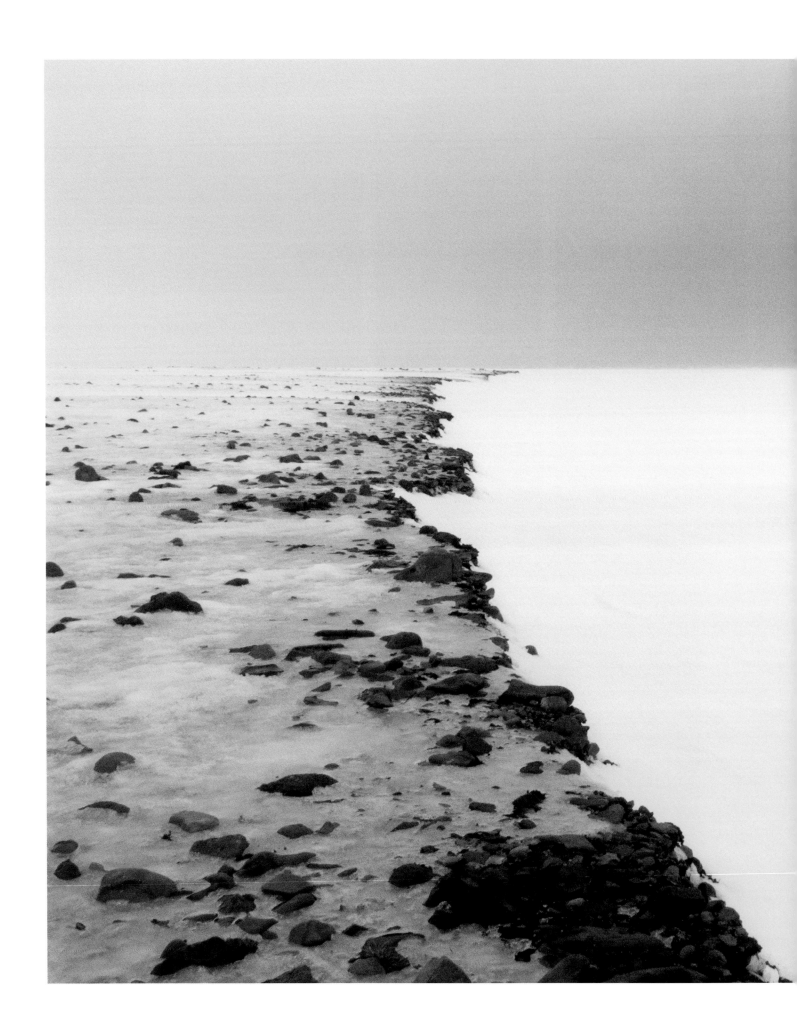

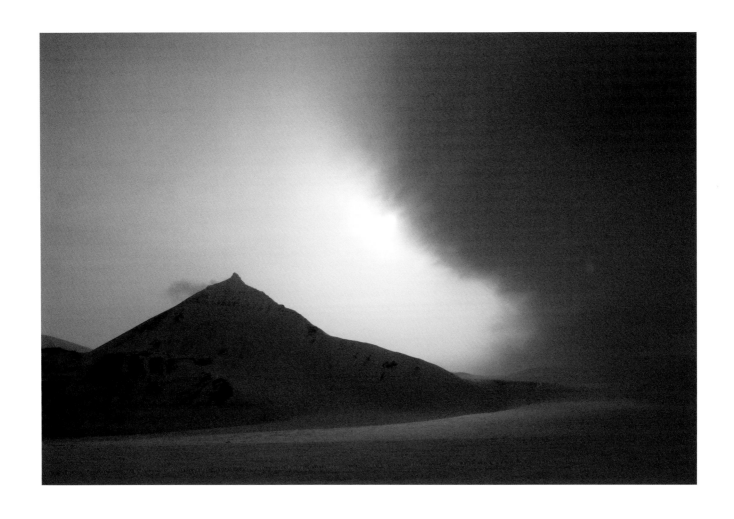

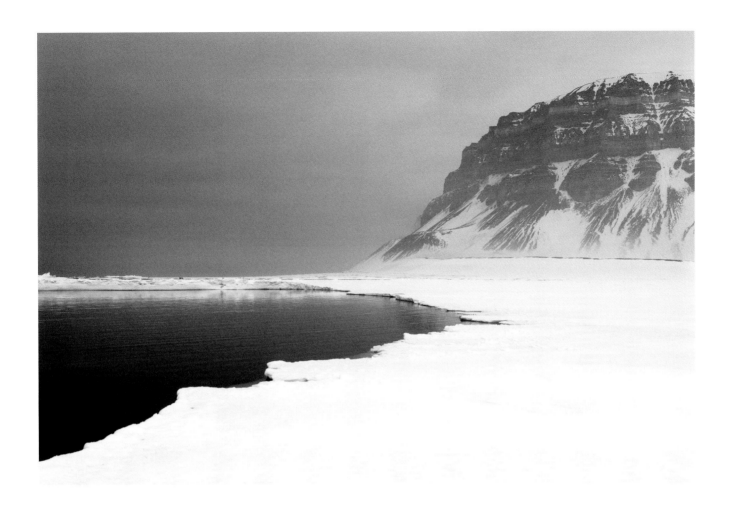

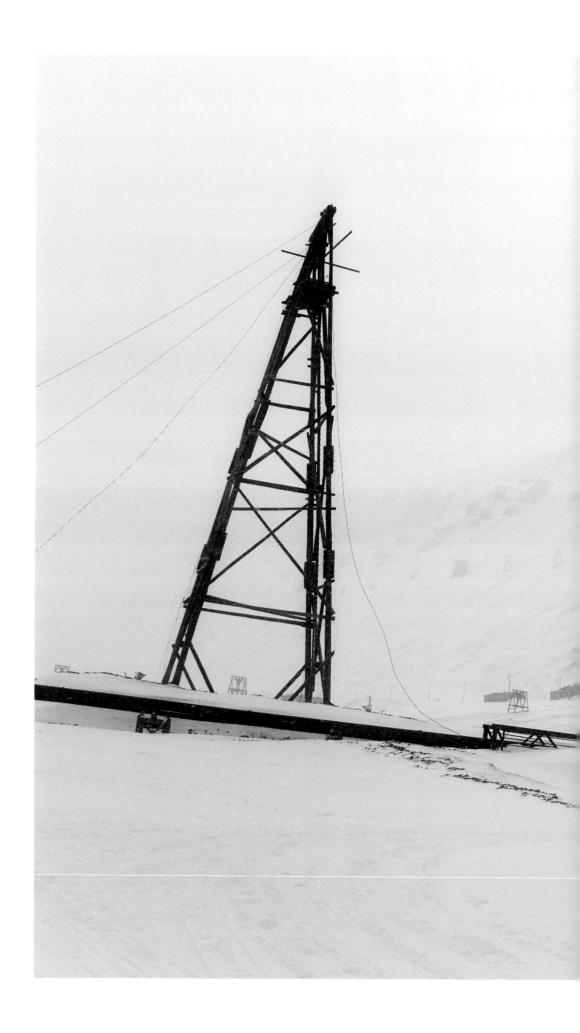

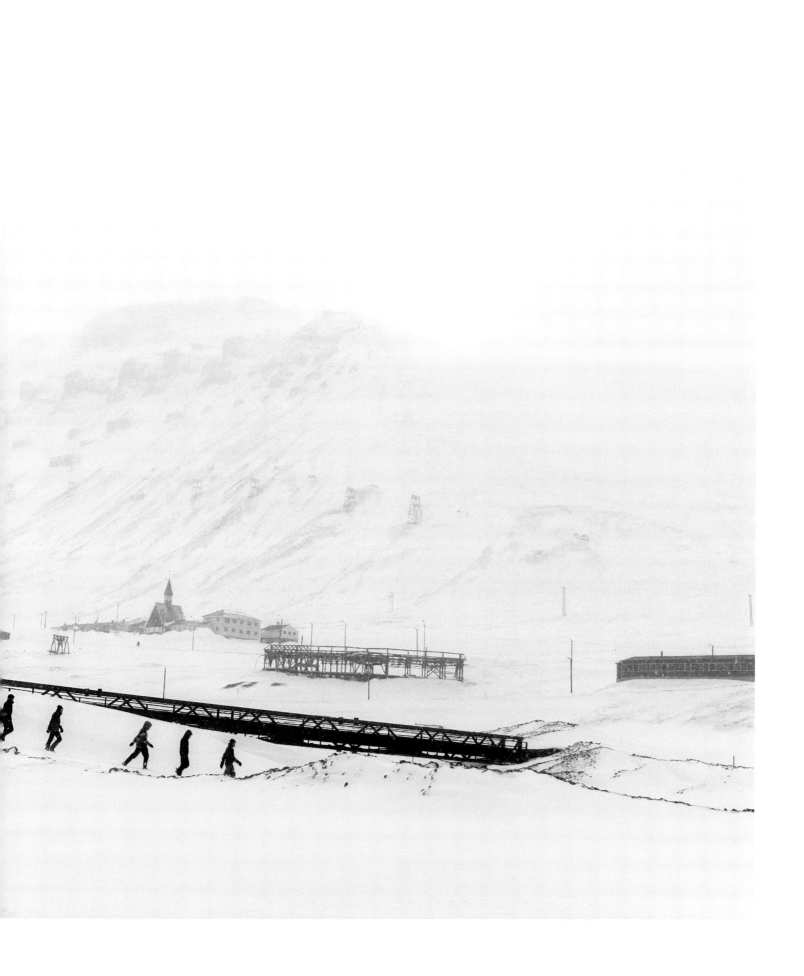

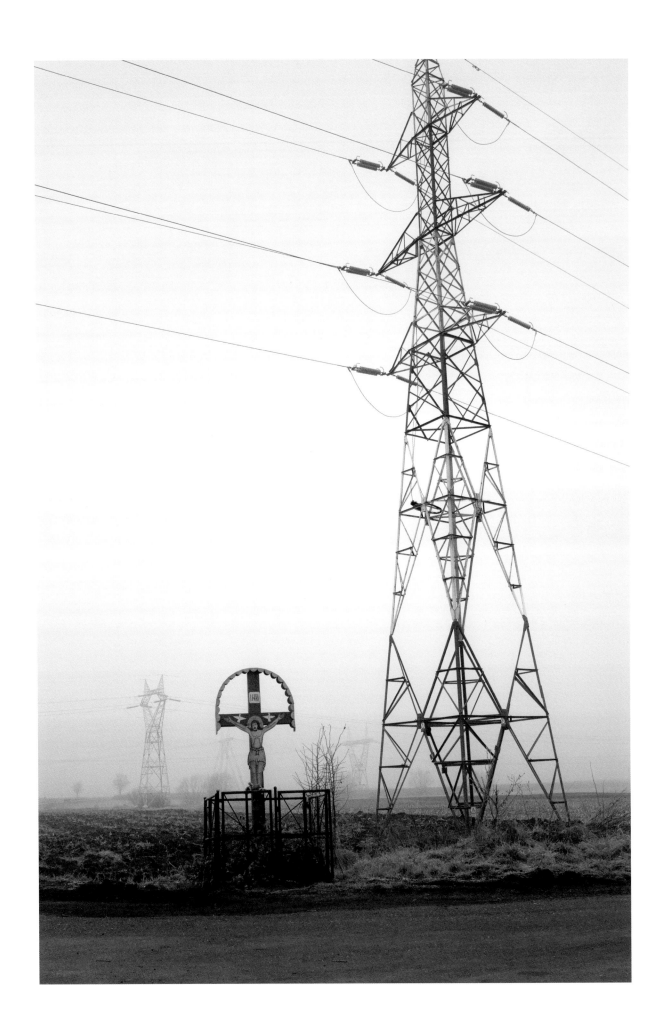

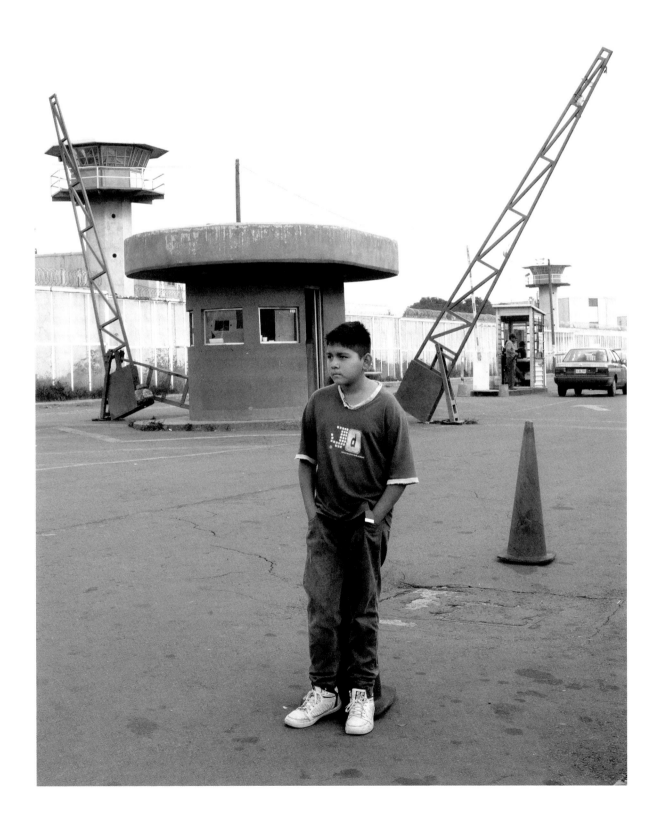

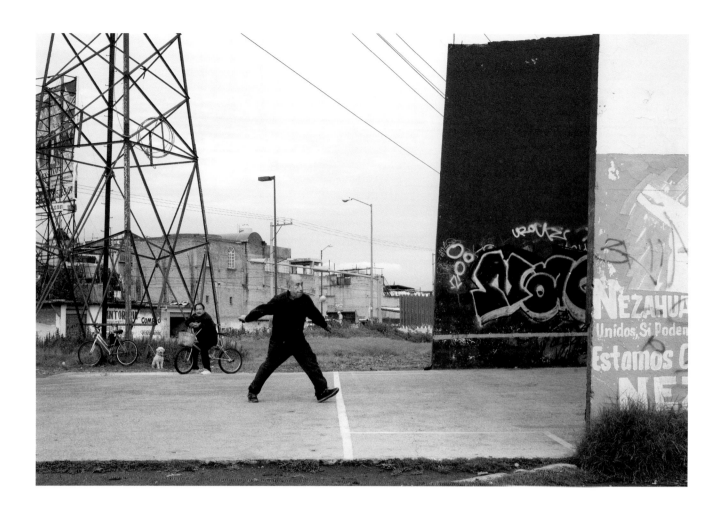

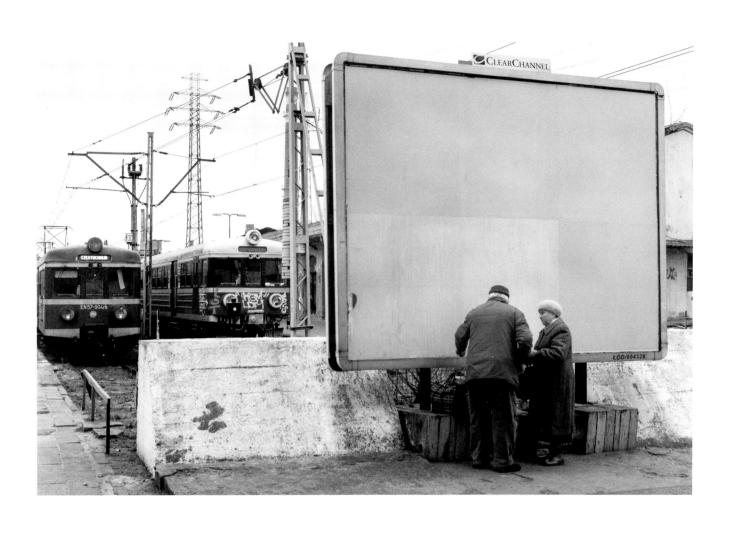

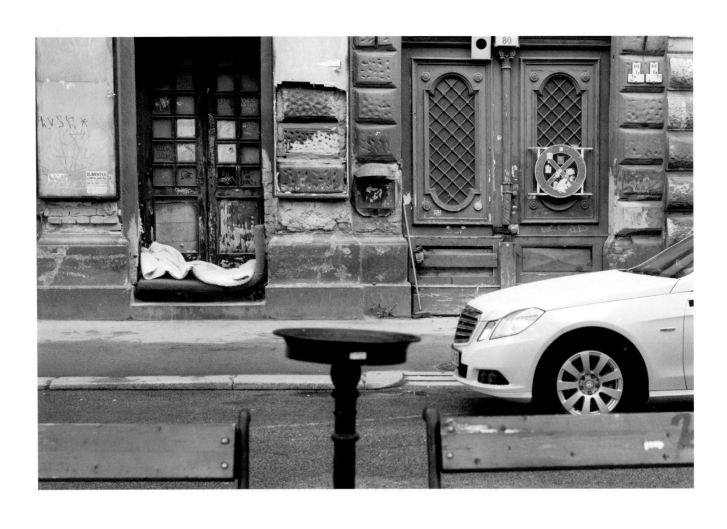

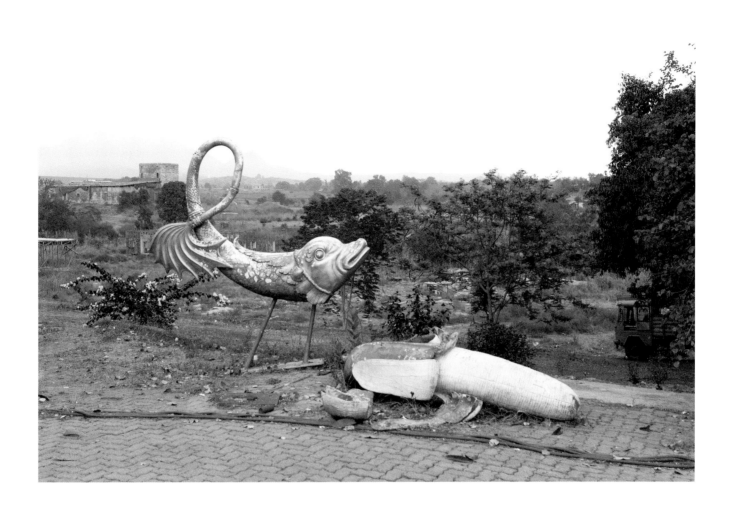

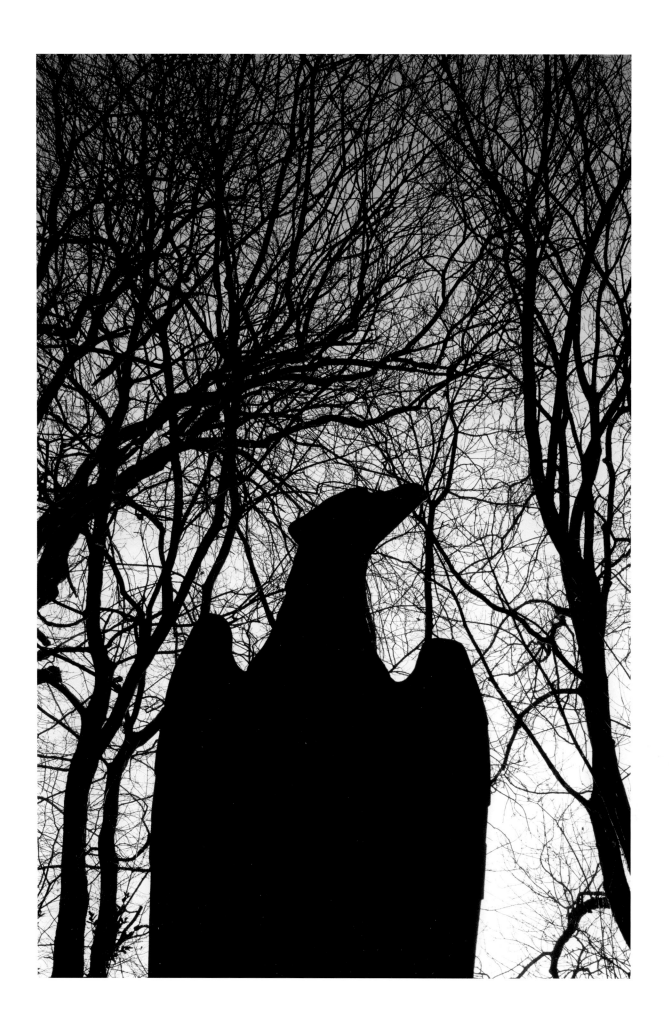

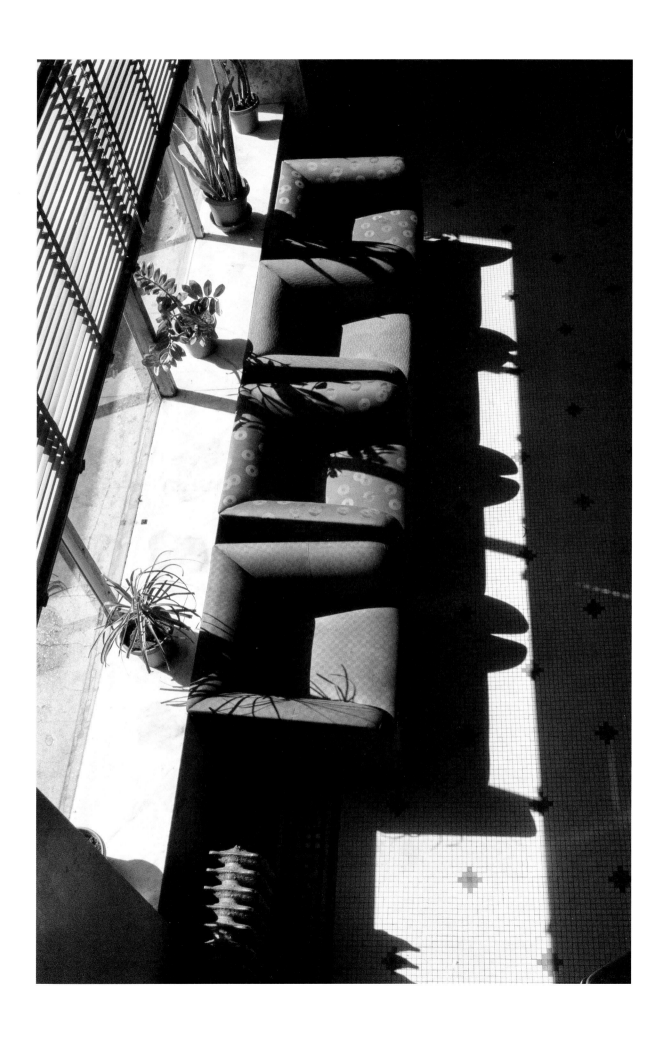

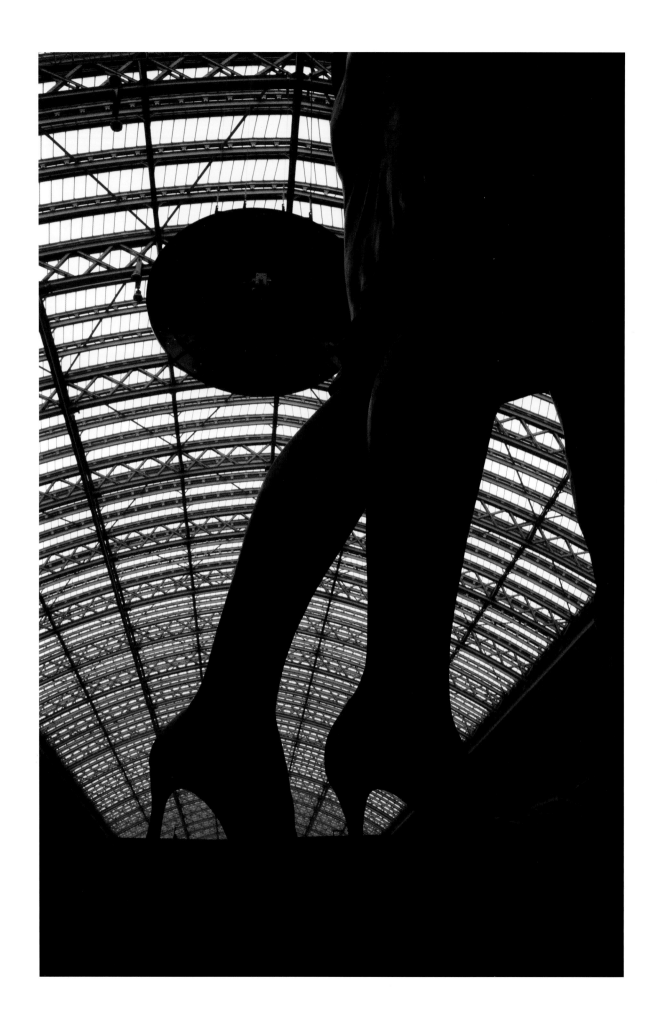

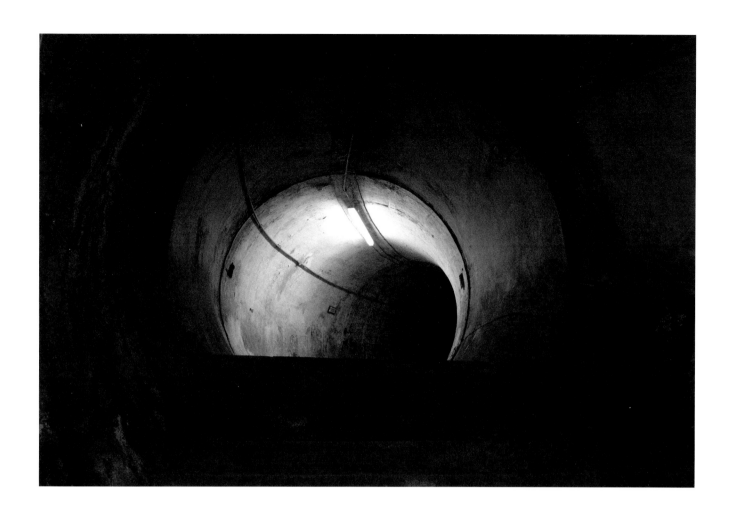

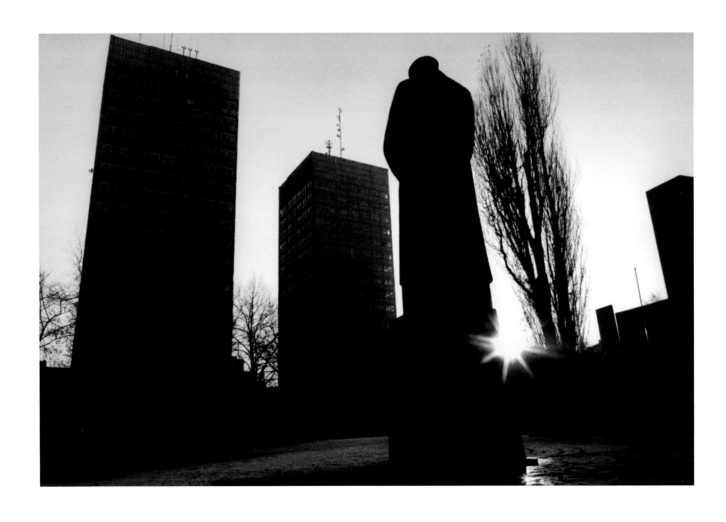

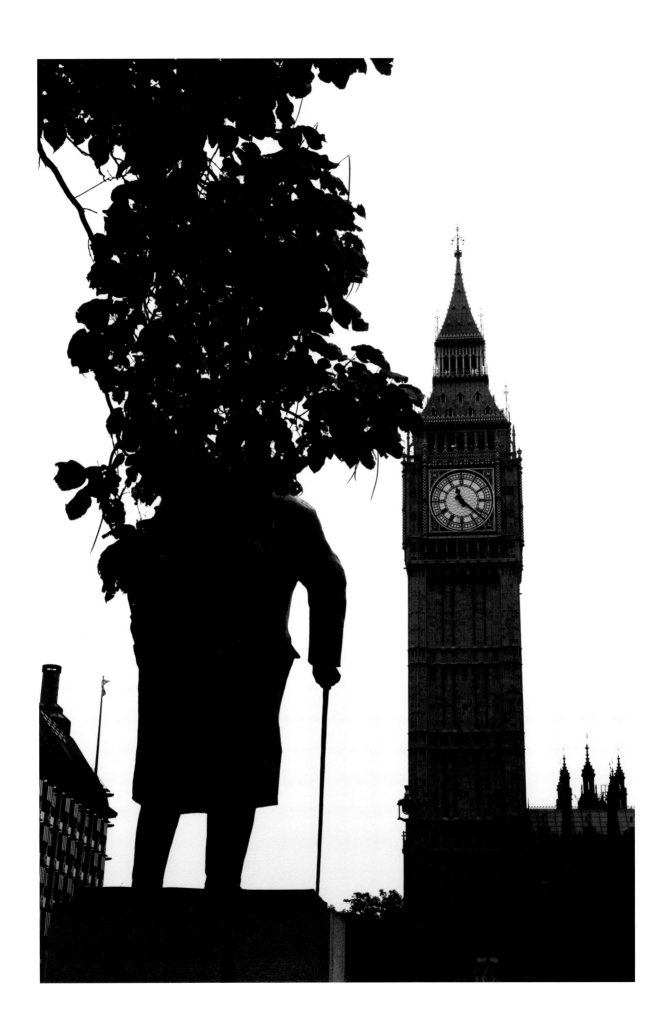

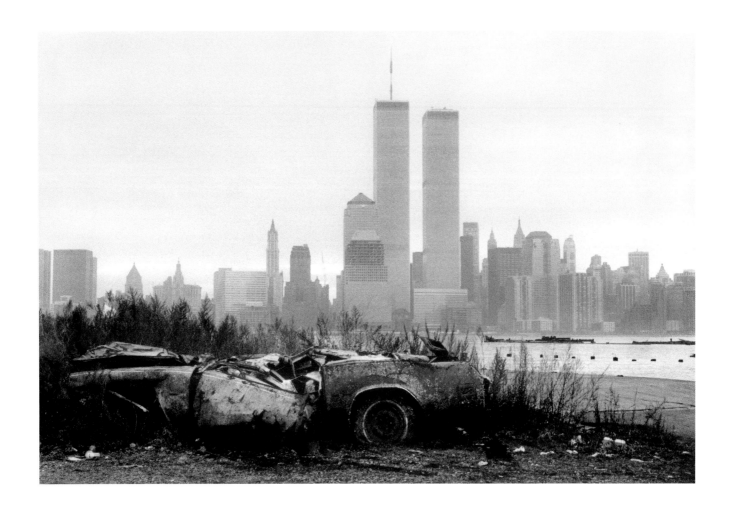

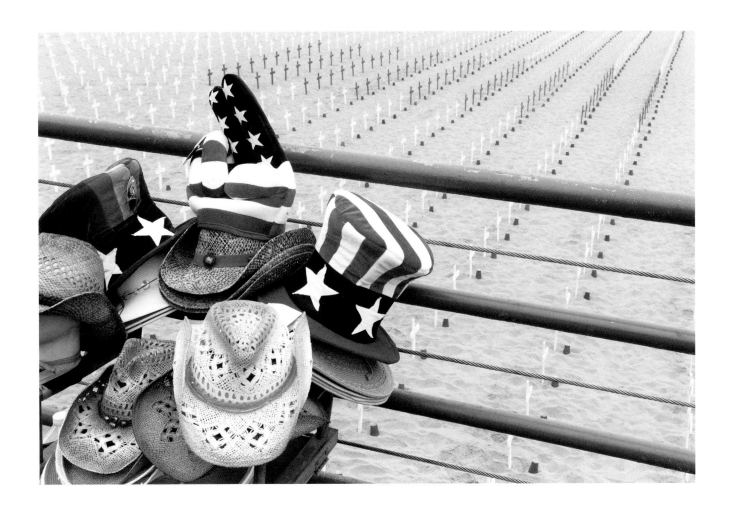

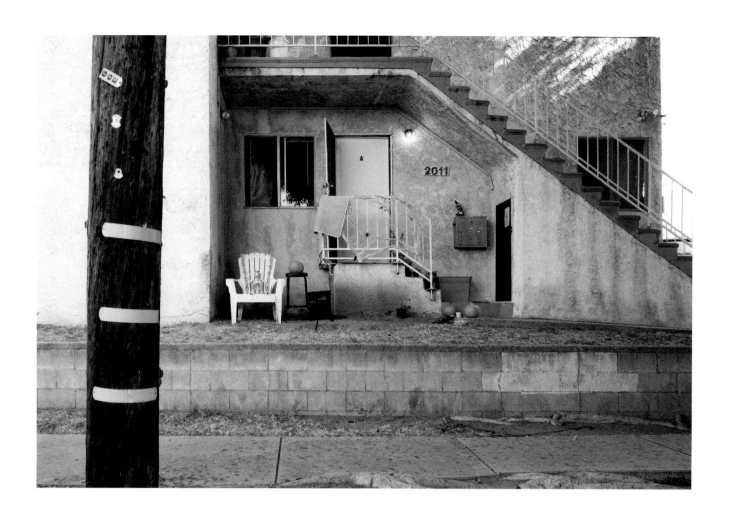

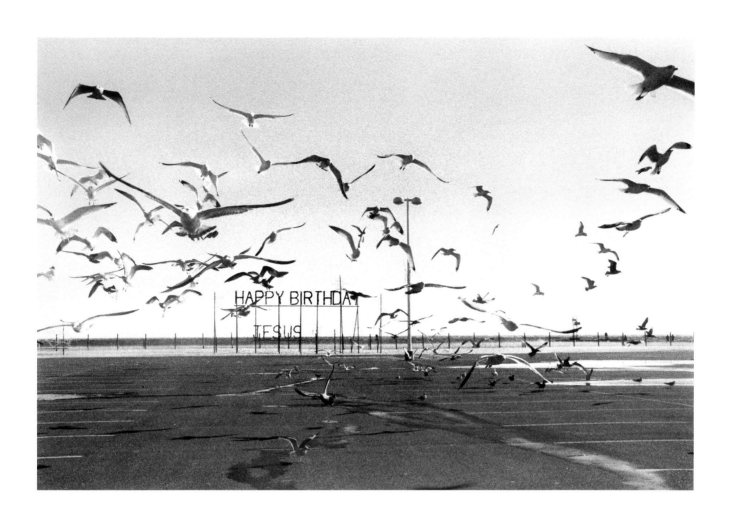

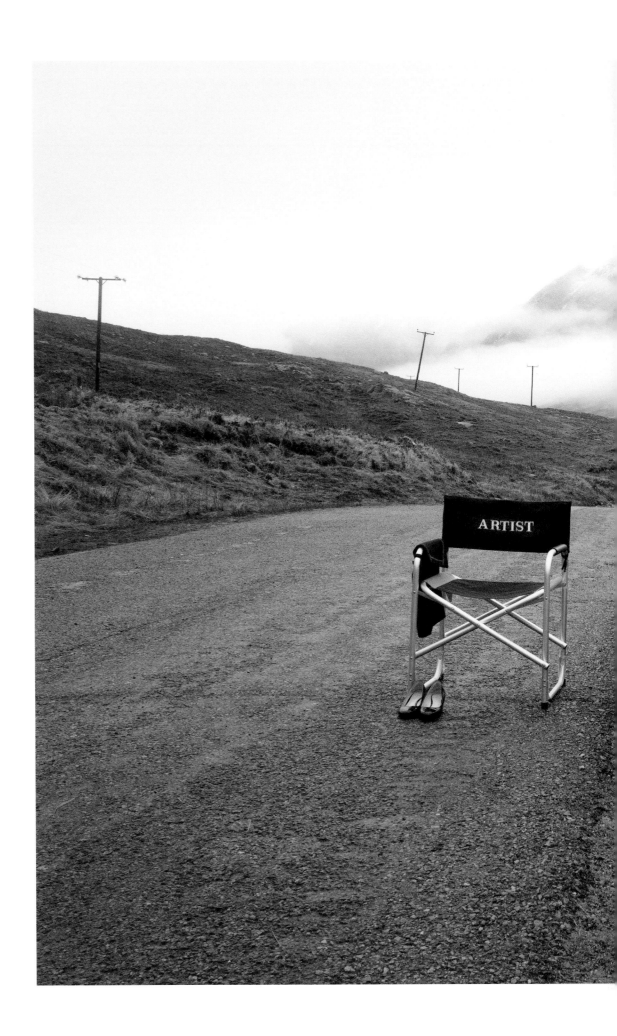

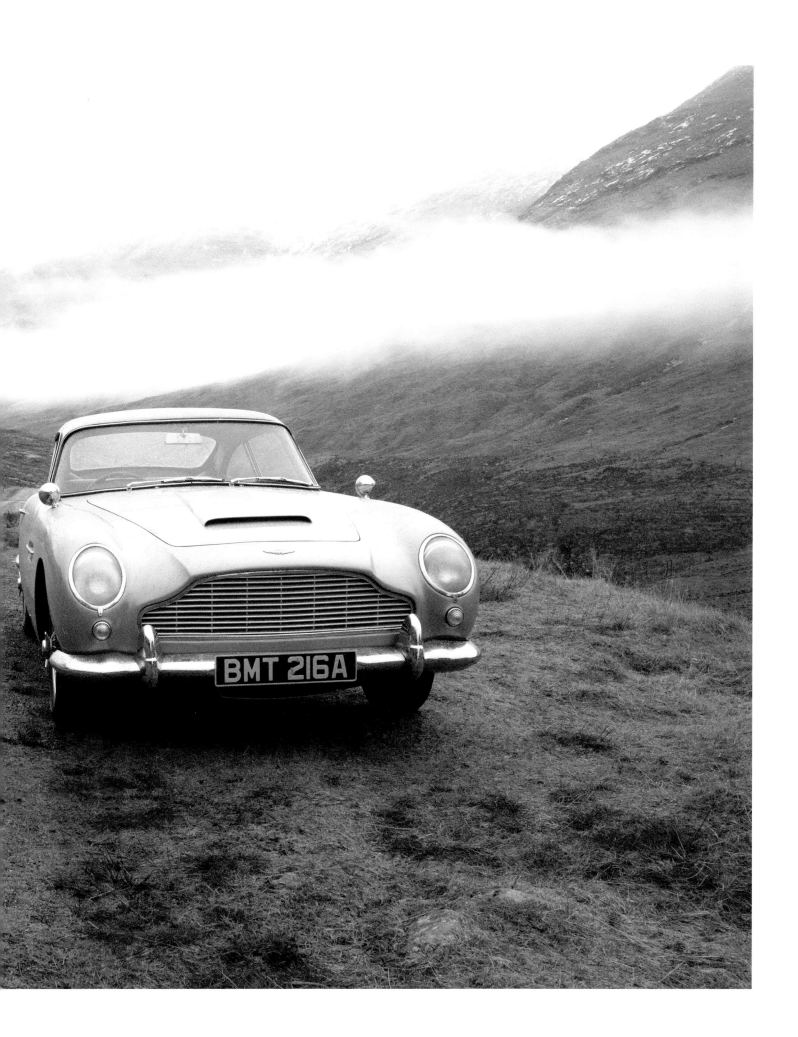

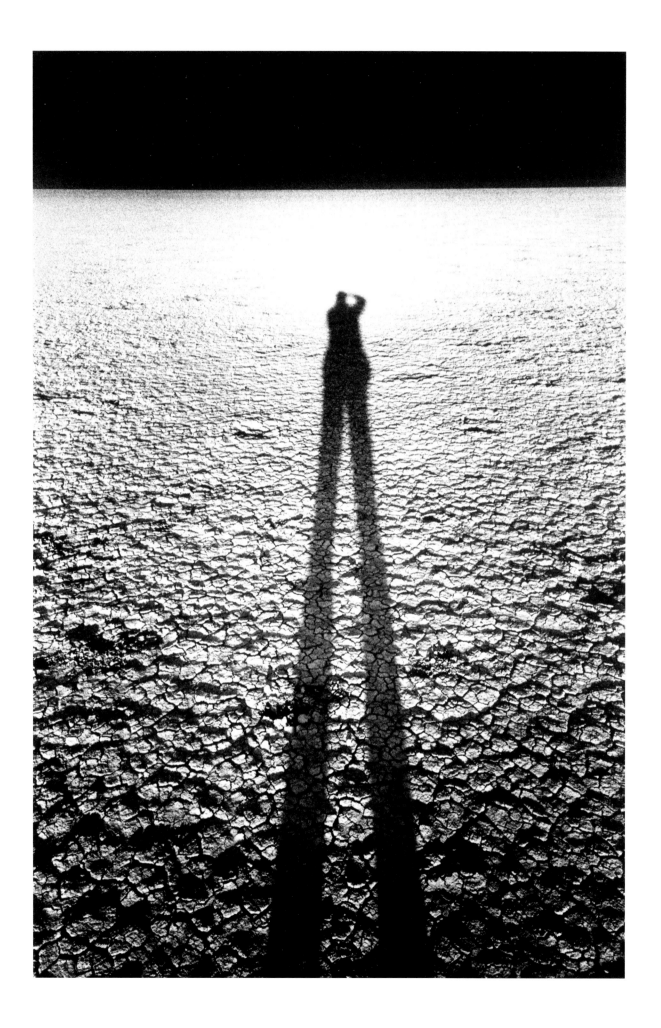

Index

Acknowledgements

I would like to thank the following for their direct or indirect help in the publishing of this collection.

Beaford Center for giving me my first photographic job that sent me down my path of visual exploration.

Beaford Archives for allowing me access to the photos. (https://beaford.org/archive)

Pete Franciosa, my agent, without whose dogged determination, this book would not be possible.

Reese Brucker, who organized us every step along the way.

Silvia Pesci, Eleonora Pasqui, Lorenzo Tugnoli and Enrico Farinazzo of Damiani Publishers who walked me through every step of the process and offered great support.

And my thanks especially to my wife, James. She has been my rock and my partner in work and in life.

BYWAYS

Photographs by Roger A Deakins

© Damiani, 2021
© Photographs, Roger A Deakins
© Text, Roger A Deakins

Published by Damiani
info@damianieditore.com
www.damianieditore.com

Printed in June 2021, Italy
Second printing July 2021, Italy
Third printing September 2021, Italy
Fourth printing November 2021, Italy
Fifth printing January 2022, Italy

ISBN 978-88-6208-751-3